# MELTON MOWBRAY

## THROUGH TIME

Stephen Butt

AMBERLEY PUBLISHING

First published 2012

Amberley Publishing
The Hill, Stroud
Gloucestershire, GL5 4EP

www.amberley-books.com

ISBN 978 1 4456 0739 9

British Library Cataloguing in Publication Data.
A catalogue record for this book is available from
the British Library.

Typeset in 9.5pt on 12pt Celeste.
Typesetting by Amberley Publishing.
Printed in the UK.

# Introduction

The present-day character of Melton Mowbray has been shaped through history by several major influences that have worked together to create a unique town.

First and foremost, Melton has been a market town for at least a thousand years. The market at Melton is one of only three markets mentioned in the Domesday Survey of 1086, by which time it was already a small but thriving settlement of some two hundred inhabitants with weekly markets, two water mills and two priests.

The origins of its name provide a clue to the town's importance as a centre for trade and the significant role in the local topography. *Medeltone,* means 'Middletown surrounded by small hamlets', and thus it has served as a meeting point for the many small villages clustered around it. Its distance from the nearest major towns has protected its independence, removed from the potential dominance of Leicester, Nottingham, Grantham and Stamford.

In the eighteenth century, foxhunting came to the area. Hugo Meynell founded the Quorn Hunt in 1753, the first of the three famous hunts to be associated with the town, which came to include the Cottesmore and the Belvoir. In 1963, the Town Estate established the New Year's Day Meet, with each of these hunts participating in rotation. Each hunt has its own historic territory, but the town's market place has always been deemed neutral ground. The hunts attracted the rich, the famous and the infamous, many of whom built substantial hunting lodges in the town. Some of these impressive buildings have survived as private residences or convalescent homes although many were demolished in the latter half of the twentieth century.

Of the infamous, it is said that the Marquess of Waterford, celebrating after a successful hunt on 6 April 1837, left his own dubious mark on the town by daubing parts of it with red paint. There is still some debate regarding the authenticity of this claim, but the popular expression of 'painting the town red', meaning having a good night out, has been employed successfully by Melton in tourist publicity, and some of its street furniture is indeed painted red.

Waterford was probably not a representative example of the local hunting community. Setting aside the hunting debate, its participants and followers brought an immense amount of prosperity to Melton. Local people were employed in building and running the hunting lodges, and in the management of the hunts. The aristocracy – including royalty – made regular visits to the town, and spent their wealth in the hotels, as well as maintaining a raft of local businesses and trades.

A third influence on the character of Melton Mowbray has already been mentioned, namely the unique role of the Town Estate that has protected not only the historic market, which now extends well beyond the original market place, but also its parks and opens spaces.

Founded in 1549, the Town Estate appears to have grown out of the earlier guilds, and the desire of the church and town to retain what was regarded as their material benefits following their dissolution. Land in the former Chapel Close, near to where the modern cattle market stands, was its first acquisition, and the initial finance for the Estate came from the sale of silver and plate belonging to St Mary's Parish Church.

Over the years, this unique enterprise has played a very significant role in influencing development in the town. It has protected land that was ripe for development, created landscaped parks and provided a wide range of recreational activities. It still manages the market, its uniformed staff prominent in the early morning bustle as the stalls are erected ready for the day's business.

Melton Mowbray is no ordinary English market town. It is the principal settlement of its area, and yet is independent of the neighbouring major towns of Nottingham, Loughborough, Leicester and Grantham by virtue of the distance between them. It

is situated on ancient routes, some of which date to Roman times, and yet is removed from both the Great North Road and the Fosse Way. It is by the side of a river, was once connected to the canal network and is still on today's rail network, yet Melton has never become a major town or achieved city status to match its cathedral-like parish church.

Its population is now more than 25,000 individuals compared with less than 250 at Domesday, and the dominance of both the church and the hunting fraternity has now diminished. It takes less than twenty minutes to walk the extent of the 'old town' from one end to the other, and from any of its ancient streets one is only ten minutes away from the market place.

In the twentieth century, Melton suffered from poor planning decisions and neglect of its heritage. To lose one ancient cross is regrettable; to lose all six of these monuments is an indication of the lack of respect for its history that held sway at that time. Significant buildings that would have enhanced the character of the twenty-first-century town were demolished, replaced by structures with a function, but of no beauty.

Yet the town's past is still alive. To be in Melton on market day is to walk in the footsteps of those who, by intention or by accident, played a role in creating the town we see today. Despite the buildings that have been lost, it is still possible to experience a true empathy with the town's rich history and heritage and to enjoy a real sense of place.

# Acknowledgements

Many Melton people have helped me in the compilation of this book, not least the shoppers and shop workers who have told me about the famous emporiums of the past and the location of buildings long gone, and who have allowed me to make use of their first-floor windows to achieve a specific view of their town.

I must acknowledge with gratitude the assistance of the staff at Melton Library, the Melton Carnegie Museum, and the Melton Town Estate who all provided advice as well as some of the archive images. The Editor of the *Melton Times* assisted in publicising my search for old images, and I must thank all the readers who responded.

I would also like to thank local author and historian Trevor Hickman, Meltonian Ken Townsend, of RAFA, the Archivist at De Montfort University, and members of the Melton Mowbray Historical Society.

I have drawn upon the standard antiquarian works for Leicestershire, which must include John Nichols' *History and Antiquities of the Town and County of Leicester* (four volumes in eight parts, published 1795–1812). A specific recognition must be made of the late Philip J. Hunt's reliable and very readable books, *Notes on Medieval Melton Mowbray* (1965) and *The Story of Melton Mowbray* (1957, reprinted 2012), as well as *The Turnpike Roads of Leicestershire and Rutland*, by Arthur Cossons (2003).

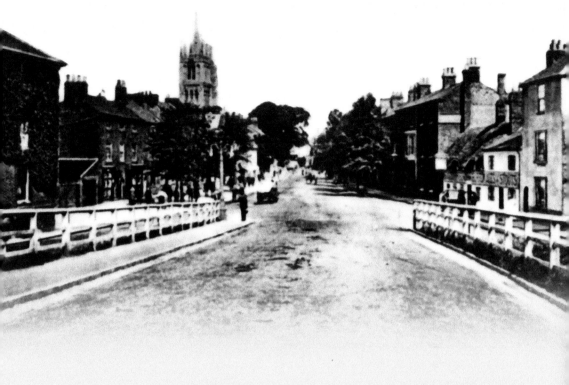

CHAPTER 1

# In the Shadow
# of St Mary's

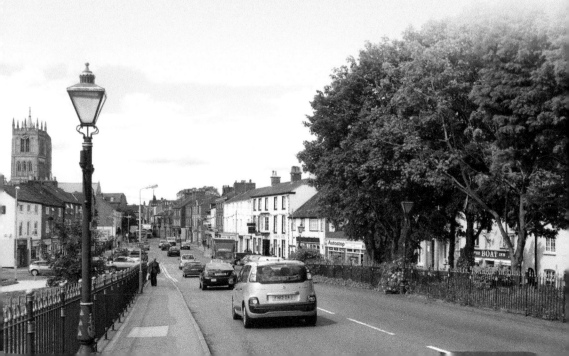

The tower of Leicestershire's largest and arguably most majestic parish church dominates the heart of Melton Mowbray. Its proportions and construction echo architecturally the cathedrals of England with their isled transepts. Nikolaus Pevsner in his *Buildings of England* described it as 'the stateliest and most impressive of all churches in Leicestershire'.

The Church of St Mary the Virgin is still at the centre of town life, its tower a sacred sundial, its shadow moving across the churchyard, adjacent cottages and market place as the day passes by.

Frederick Attenborough, who combined his love of photography with his academic interest in local history, took photographs of St Mary's for inclusion in books by the founder of the academic study of English local history, William George Hoskins. His photograph of the Galilee Porch is included in this collection.

Not far from the church is the river, a source in earlier times of food and a means of travel. Here, as it flows beneath the Burton Road Bridge, it is known as the River Eye; but later, after Leicester Road, it becomes the River Wreake, a descriptive Danish name meaning a tortuous, twisting and turning course, and later still it becomes the River Soar.

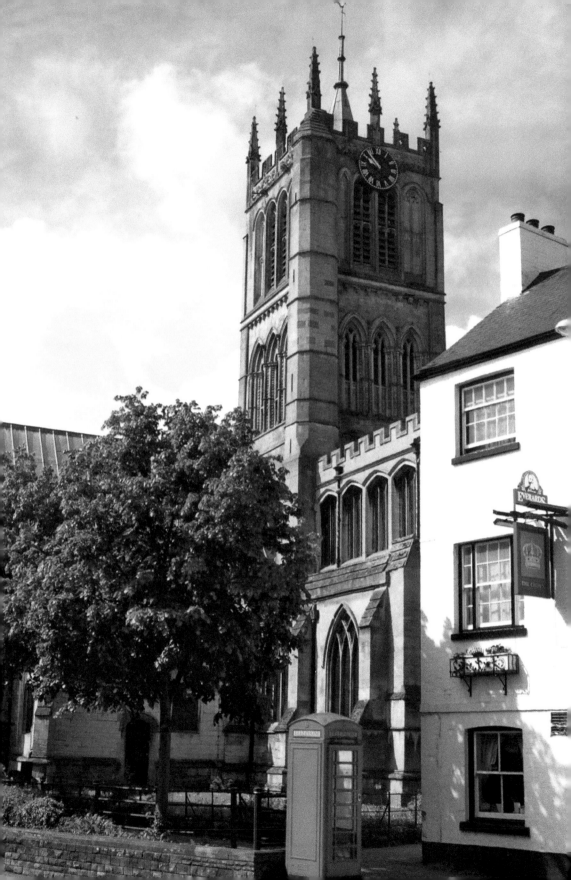

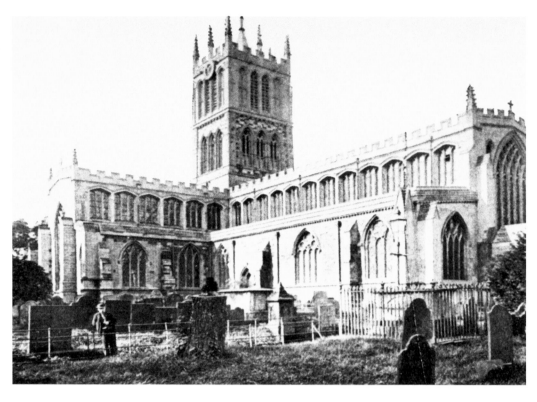

St Mary's Parish Church

Melton Mowbray's fine parish church is almost certainly on the site of an earlier religious structure. Domesday records the presence of two priests in Melton. Its richness reflects the past influences and money of the merchant guilds.

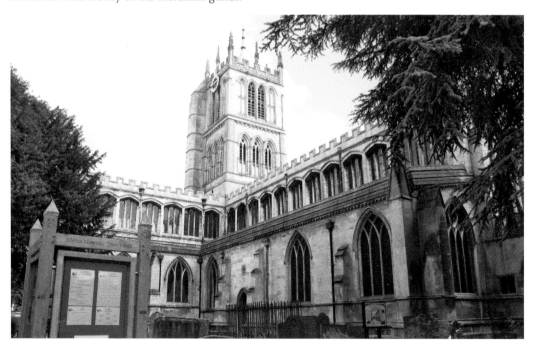

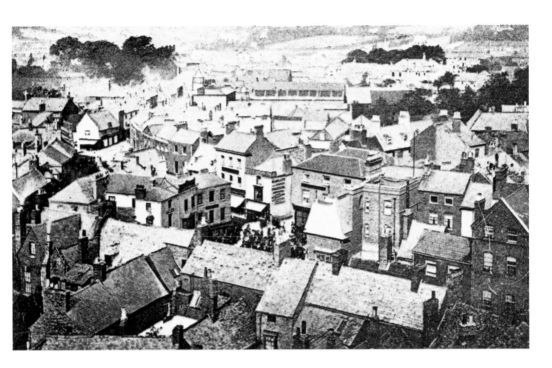

## The Precincts of St Mary's

The nineteenth-century rooftops of the old town, viewed from the tower of St Mary's in about 1900. Although many of these buildings have been altered or demolished, some of the earlier cottages in the shadow of the church have survived. The slate memorials provide an unusual addition to a cottage garden.

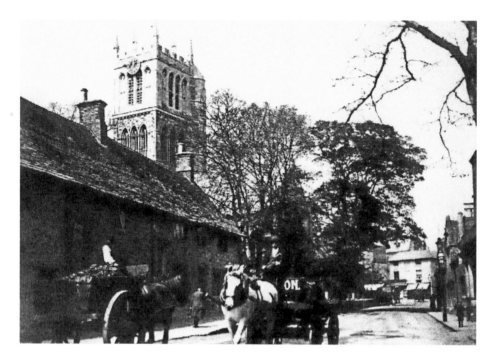

### Anne of Cleves' House

Apart from the church, Anne of Cleves' House is the only building in the town that dates from the medieval period. From 1538 until his execution in 1540, it was owned by Thomas Cromwell, Lord Chancellor to Henry VIII. His possessions were forfeited to the Crown and the revenue made up Anne's divorce settlement. It was probably built to house chantry priests, and has been used as a residence for the vicars of Melton. It is now a pub.

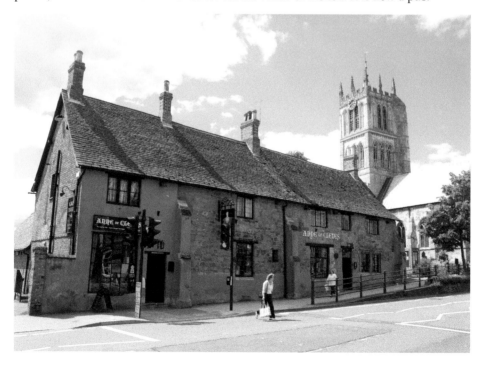

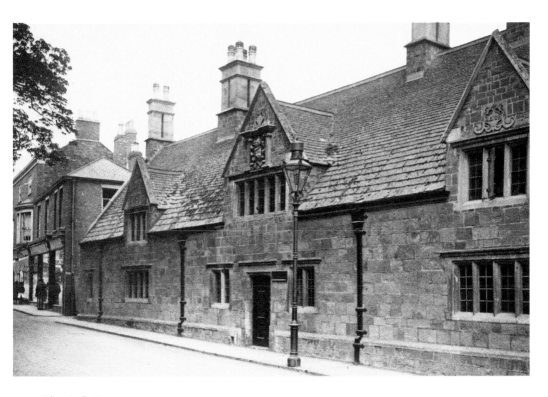

### The Bede Houses

These almshouses were founded in 1641 by Robert Hudson, a local man who became a wealthy and respected London merchant. Over the door is carved *Maison de Dieu*, meaning House of God. The central first-floor room was used formerly as the town's museum.

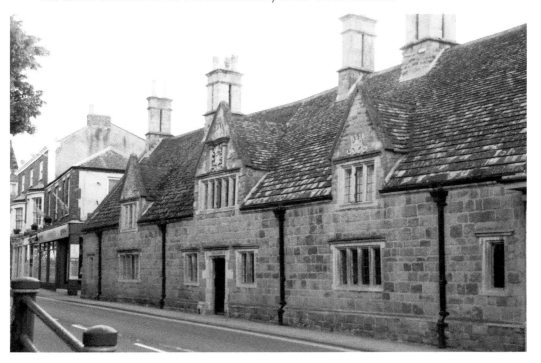

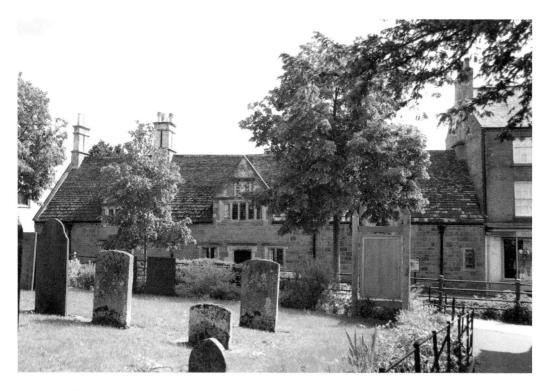

### Robert Hudson

Hudson was a leading member of the Guild of Haberdashers. The Guild's crest, together with his own coat of arms, were originally set within the front windows, and are now to be seen in the ancient glass in the windows of the south aisle of the parish church. The vicar received an annual bequest to give a sermon in the Bede Houses on each Plough Tuesday.

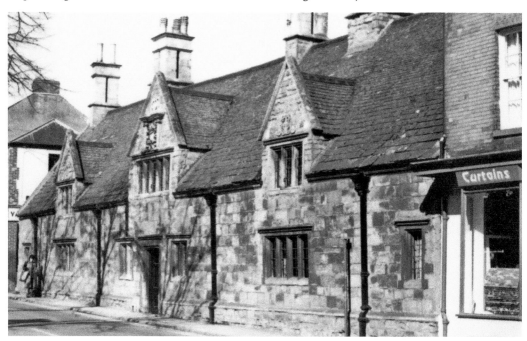

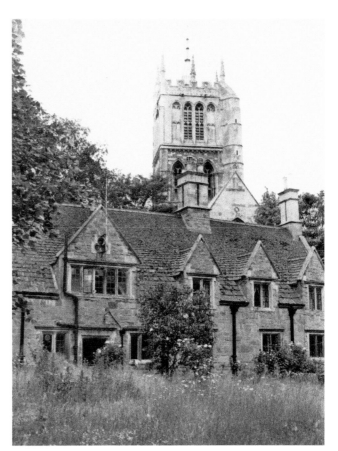

**The Bede Houses**
After over 350 years, this old
building is still being used for
its original purpose. Robert
Hudson originally planned
his endowment to care for
'six poor old bachelors or
widowers'. A later benefaction
provided care for 'six old
ladies', each with their own
room and regular provisions,
both physical and spiritual.

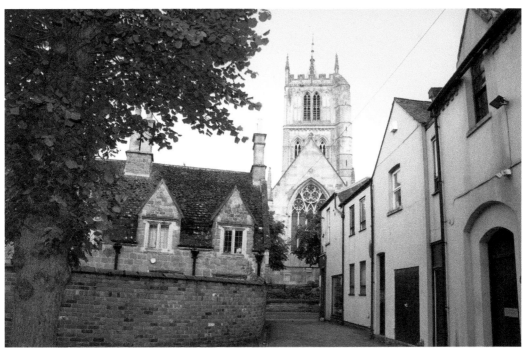

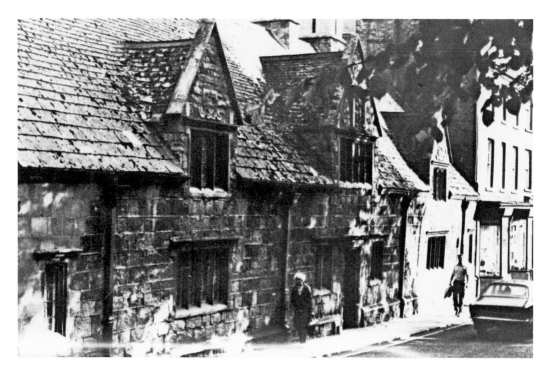

### The Bede Houses

As with many ancient buildings, Hudson's Bede Houses has survived several attempts at restoration. The most significant and damaging occurred in 1891, and is recorded in the stonework above the dormer windows in lettering far more prominent than the earlier inscription above the front door.

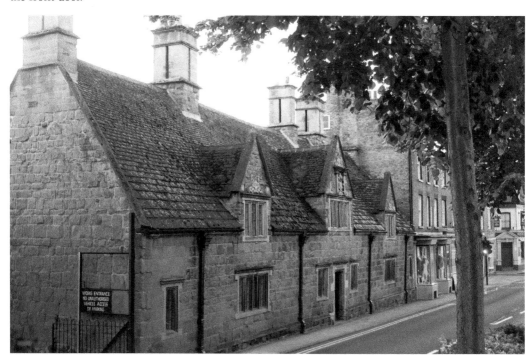

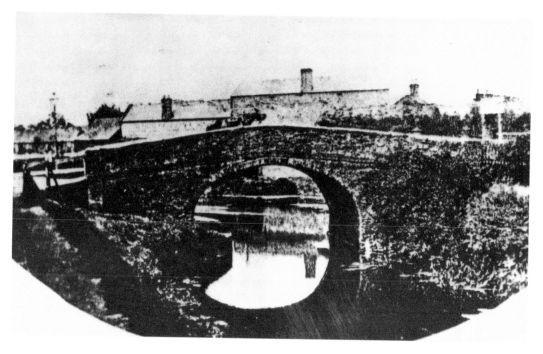

### Burton Road Canal Bridge

An example of how the railways replaced the canal network, the Oakham Canal, following the course of the river, was opened in 1802 but was never successful financially. It closed in 1847 when it was purchased by the Midland Railway. The canal was mostly filled in, with the railway following part of its course. The modern Burton Bridge, erected in 1900, spans the railway lines running into Melton Station, and the original watercourse.

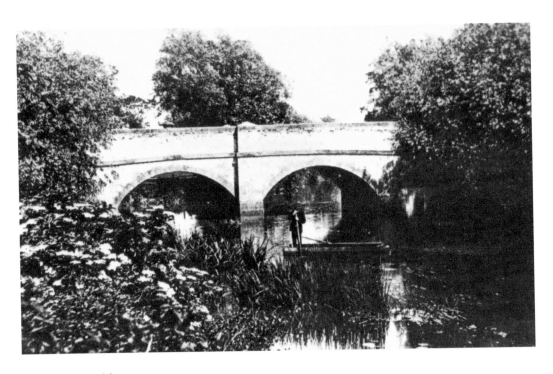

## Burton Road Bridge

This older photograph shows the bridge in about 1920 and suggests a tranquil scene with the canal still navigable, at least by small craft. From nearby Ankle Hill an overgrown and very wet path leads through trees to where the towpath once ran.

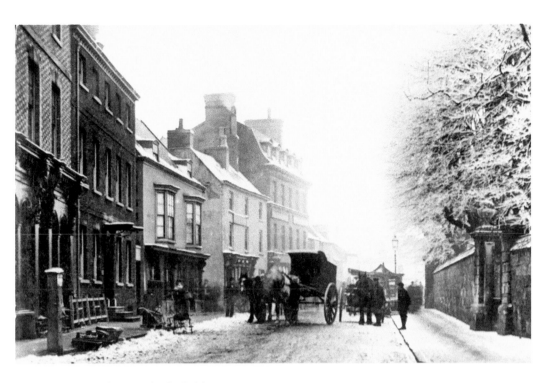

**Burton Road Towards the bridge**

The atmospheric nature of this early photograph of the Burton Road looking towards the canal and railway is created by the horses delivering coal, the distant gas lamp and the pump. Today, the street 'clutter' is prevalent, the A-boards outside the shops and the road signs. Behind the line of trees is Anne of Cleves' House.

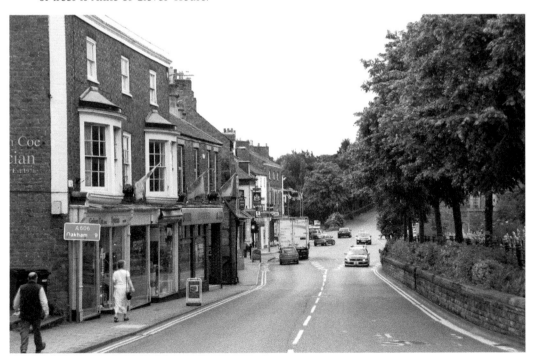

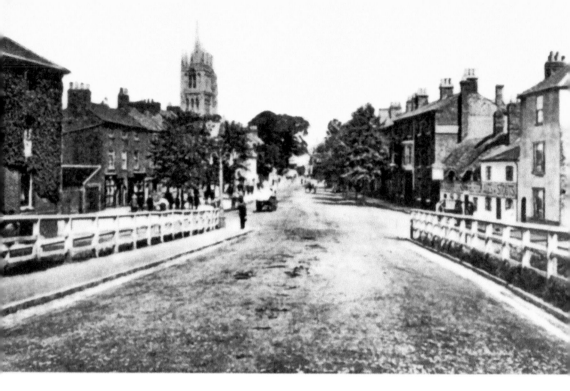

**Burton Road Towards the Town**
This is the opposite view to the last two photographs. The earlier photograph dates to 1900. The tower of St Mary's is prominent today, as it has been for so many centuries. Opposite the church stand the Red Lion public house and the Harboro coaching inn.

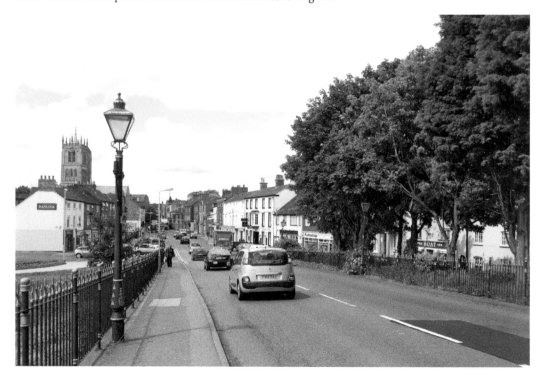

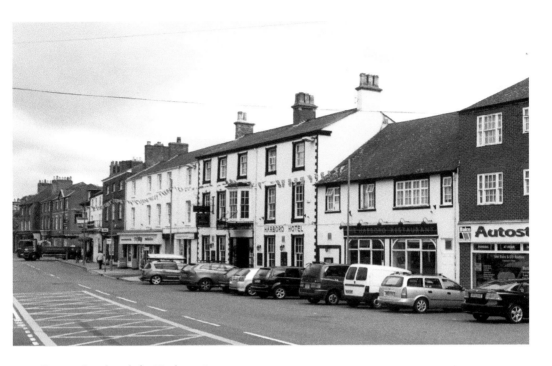

**Burton Road and the Harboro Inn**

A former coaching inn, the Harboro has been in existence since the eighteenth century. In recent years it has struggled to survive the changing tastes of modern travellers, but was refurbished and reopened in 2011. Nearby is the former residence of Sir Malcolm Sargent, the famous conductor, who was organist at St Mary's parish church between 1914 and 1924 at the beginning of his musical career.

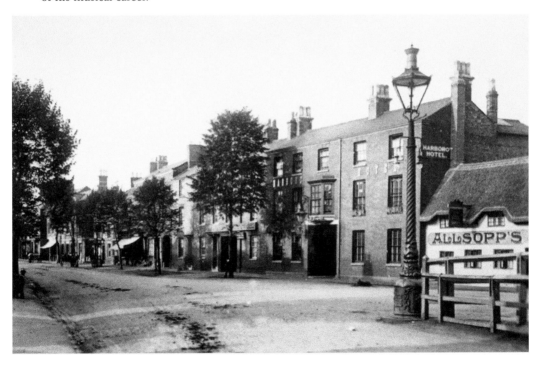

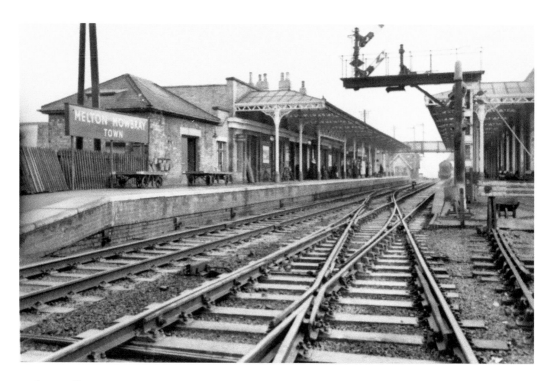

Melton Railway Station

Viewed from the Burton Road bridge, the railway station looks almost too clean and smart. The older image dates from the 1950s. The station was opened in 1848 and has been much altered over the years, although the Edwardian charm is still evident.

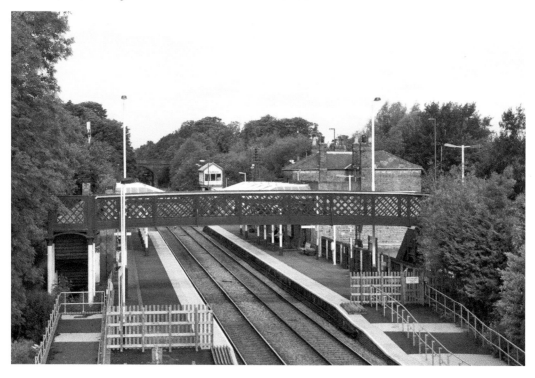

**St Mary's Galilee Porch**

The earlier photograph is by Frederick Attenborough, and was taken to record the architecture of the entrance to the church closest to the market and the town centre. It has suffered from rather clumsy restoration in the nineteenth century by George Gilbert Scott.

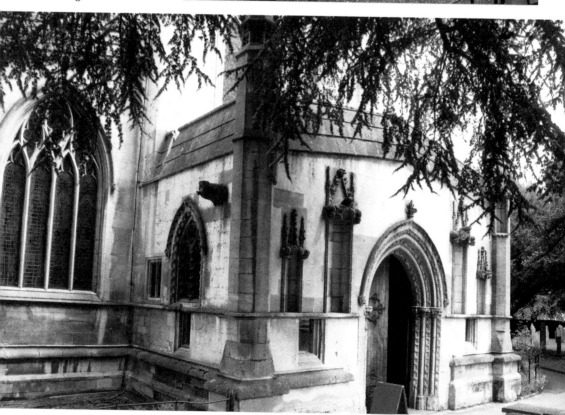

CHAPTER 2

# The Limes & The Elms

The old buildings that are most at risk from demolition tend to be those that find themselves in the way of economic development in the centre of towns. Whereas on the outskirts some of Melton Mowbray's former hunting lodges were converted, with a degree of success, to serve as hotels or convalescent homes, in the economic heart of the town these old residences lost their battle to survive.

The Limes was a solid and dignified residence that dated to the seventeenth century. Originally it was the home of Robert Hudson, the founder of the Bede Houses in Burton Street, and it was almost certainly built on the site of an even older building.

Records indicate that 'great rejoicings' took place at The Limes at the end of the English Civil War, led no doubt by Robert's son, Sir Henry Hudson. The house, in the words of former local historian Philip Hunt, 'was built, as was the church, of brown and grey stone, with its fine doorway and stone mullioned and transomed windows. This handsome building was a joy to the beholder.'

The Limes was later to become a popular residence for the hunting fraternity. *Bailey's Magazine* for January 1901 reported

> The Duke of Roxburgh has been out in the Atherstone country. Captain Doggie Smith has been on a visit, and has had a fall with the Belvoir. Lord and Lady Winchester are at Cold Newton, and Prince Demidoff and the Princess (both of whom shared in a late adventurous hunt for Ovis Amnion) are at the Limes.

But despite having a significant place in the history of the town, The Limes was demolished in 1932 to make way for a Woolworths store facing Sherrard Street. Following the demise of the retail group in 2009, the shop was occupied by the Yorkshire Trading Company, which, somewhat ironically, is a major supplier of outdoor clothing for country pursuits.

Set back on the opposite side of Sherrard Street was The Elms, another impressive residence. It was built in the last decade of the eighteenth century with extensive gardens and outbuildings. These were gradually sold off and finally the house was demolished. A telephone exchange now stands on the site, and a small housing estate in its grounds.

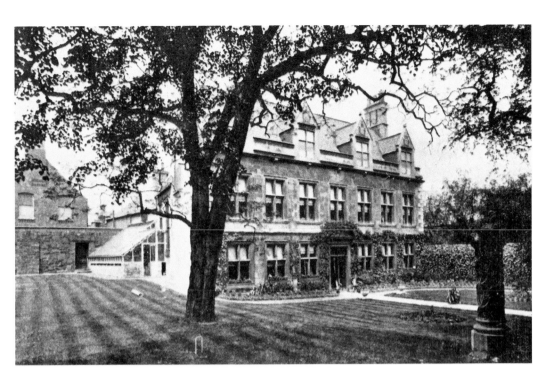

The Limes

A rare photograph of The Limes in its heyday, with its flower borders in perfect order and its well-manicured lawns. This was one of Melton's most popular lodges for the hunting families. The owners included Lord Wilton, Duke of Portland, Prince Demidoff and, in its latter years, James Pacey JP.

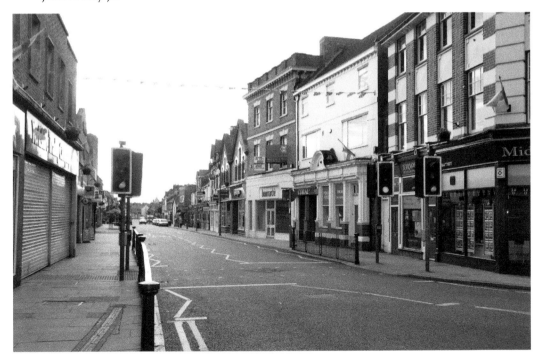

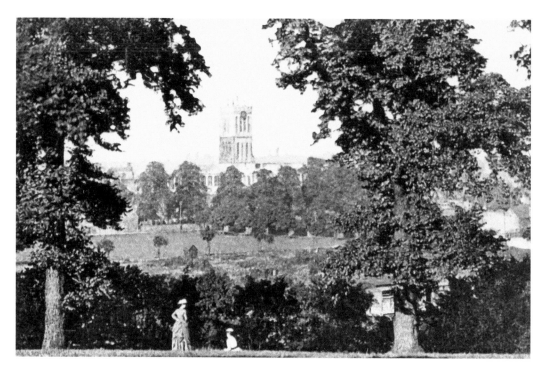

### St Mary's from The Limes

A leafy view of the tower of St Mary's rising above the market place, which can no longer be experienced. The earlier photograph was taken from within the gardens of The Limes. The angle of the tower and the church clock indicate the approximate view today.

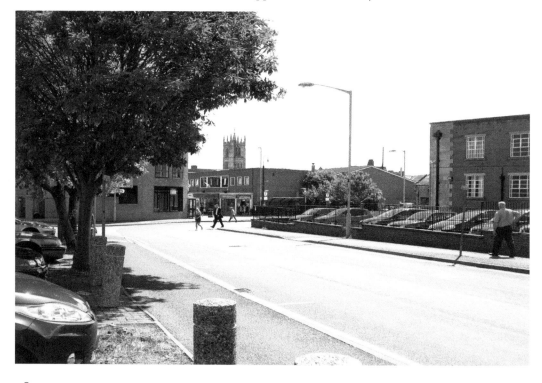

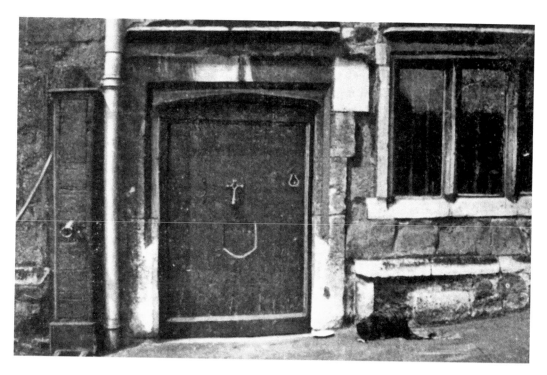

### The Limes' Bread Door

The only surviving relic of The Limes is the ancient alms door or 'bread door'. Food was passed out through the shield-shaped aperture to the poor, probably in times of plague and sickness. The door and its surrounding wall are now built into the western side of Egerton Lodge on the Wilton Road.

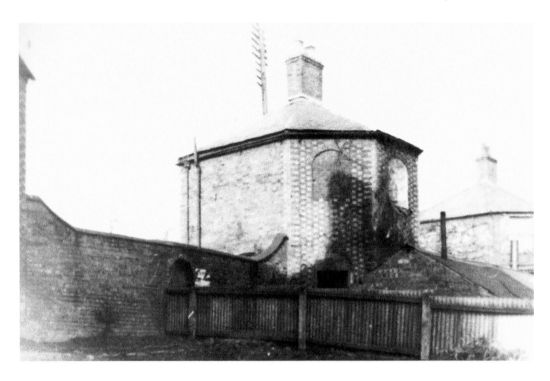

## The Round Houses, Sage Cross Street

These curious structures were built by an owner of The Limes to provide a home for three maiden sisters. Each was octagonal in shape with three rooms and with gardens of exactly the same size. One of the buildings survived until recent times when it was demolished to make way for a medical centre. The street name refers to the site of the ancient Sage Cross, which stood nearby.

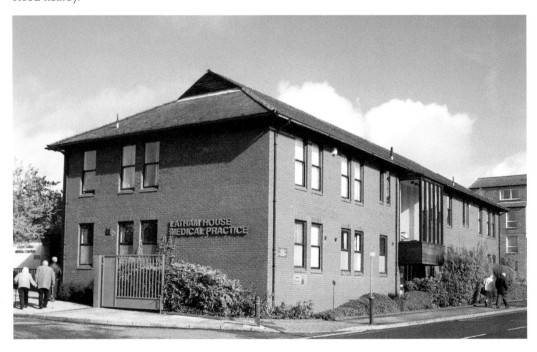

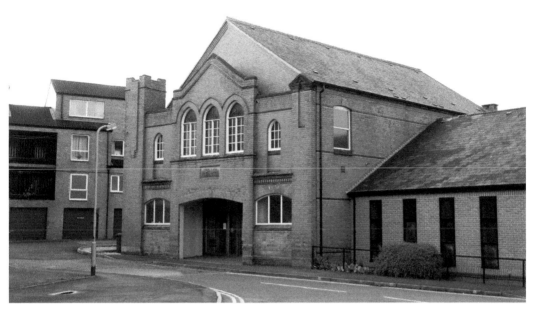

### Sage Cross Street, Wesleyan Methodist Church

The original church on this site, which was constructed in 1871, was demolished when the adjacent supermarket was built. The Sunday School and hall, part of the original structure, were retained, to which a new and smaller church has been added. The first Methodist chapel in Melton opened in 1796 when the number of Wesleyans in the town numbered just eleven worshippers. It was enlarged in 1825, by which time the congregation had reached one hundred.

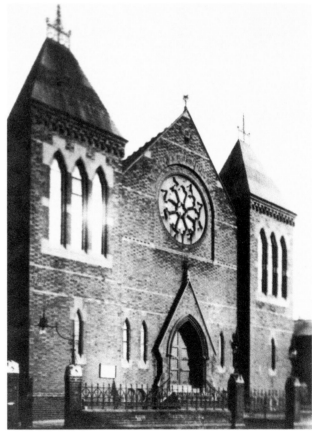

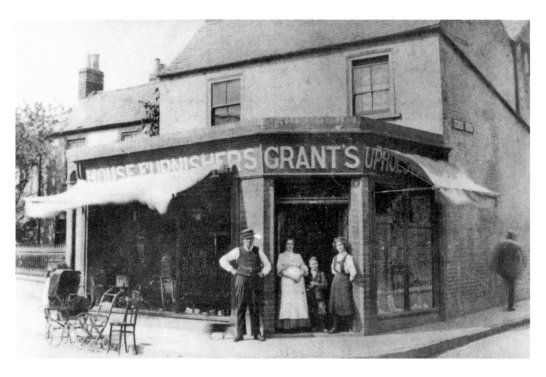

**Bentley Street**
Bentley Street adjoins Sage Cross Street, and is in the former precincts of another hunting residence, North Lodge. It was built in about 1860 by a local brewer, Captain Adcock. Later, these little streets became home to a working-class community. Sadly, the corner shops have vanished.

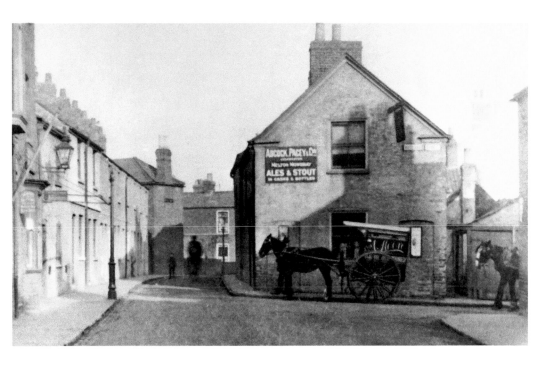

## Rutland Street

A similar story can be told in nearby Rutland Street, which runs parallel to Sage Cross Street. There is now little trace of the original terraced rows. New residential developments have obliterated much of the original street plan.

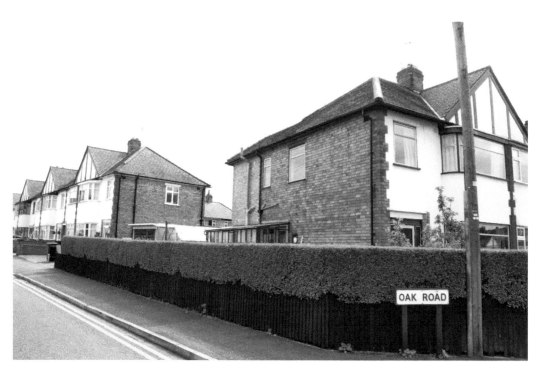

### The Elms

Another lost hunting lodge of great dignity, which dated from the 1790s. In the older photograph, part of the building can be seen facing Sherrard Street. Elms Road and Oak Road were built on the grounds.

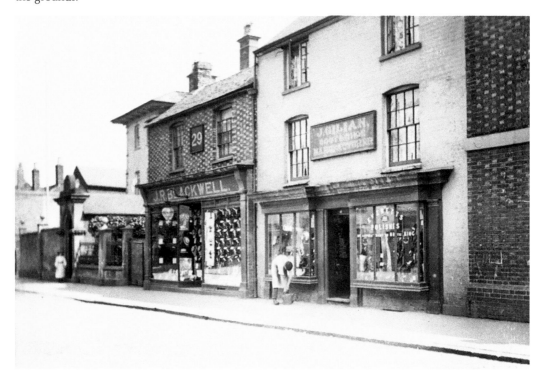

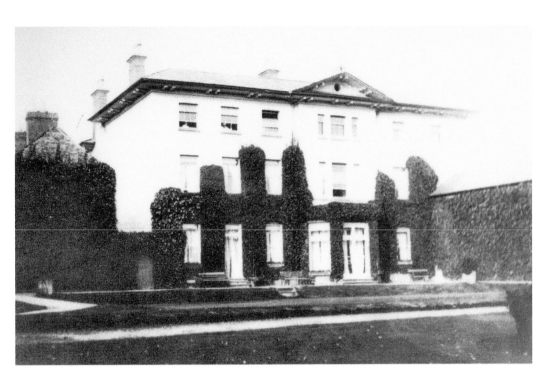

## The Elms off Sherrard Street

A telephone exchange was constructed on the site of the The Elms, which in the age of digital communication is largely redundant, leading to an air of decay. In the dark corners, the graffiti artists have taken over. However, excavations prior to its construction revealed the existence of very early high status buildings, possibly ecclesiastical, and perhaps the later abodes of Melton's wealthy wool merchants.

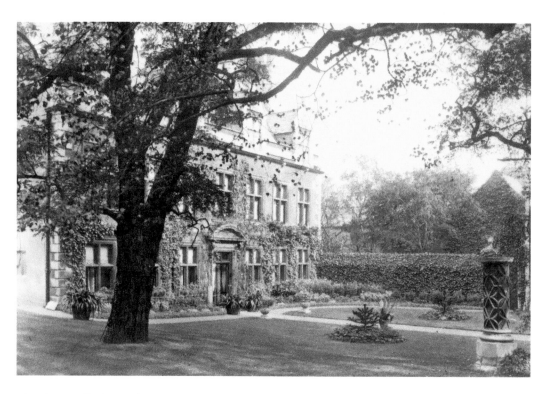

### The Limes, off Sherrard Street

The front boundary wall of The Limes ran along Sherrard Street. Its location was where the Yorkshire Trading shop, formerly a Woolworth store, now stands, on the left in this recent photograph. The adjacent building was formerly an agricultural engineering business and later a Ford motor vehicle showroom.

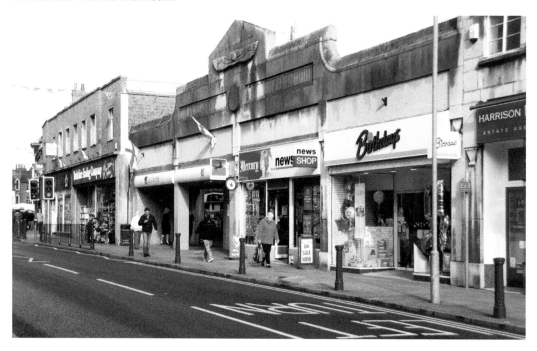

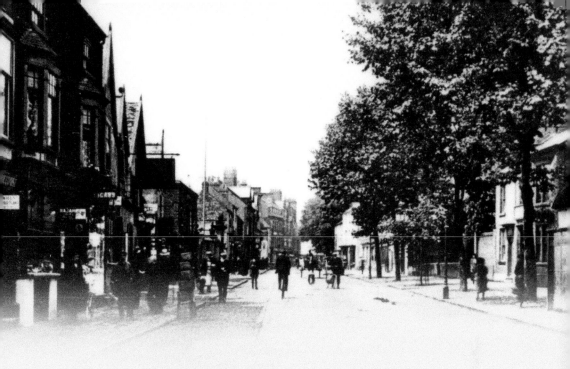

CHAPTER 3

# Thorpe End to
# South Parade

The modern route towards the market place from Thorpe End begins at the site of the ancient Thorpe Cross. Here, two important routes from the Great North Road – from Grantham and from Colsterworth – came together at a crossing where the Scalford Brook formed a natural western boundary to the town.

The road from Colsterworth at this point was known as Brentibigate, from the small hamlet of Brentingby that lies off the Colsterworth Road.

Crossing the brook, travellers entering the town would reach Saltgate, the modern Thorpe End. Saltgate takes its name from the Roman 'Sawgate' road. This was a main route from the coast by which salt was traded into the interior of Britain. It still exists as a defined route in nearby Burton Lazars.

At the Sage Cross, the route became the Beast Market, which led to the High Cross or Butter Cross in the market place. Near the Sage Cross was the ancient vegetable and herb market. The cross itself was located opposite The Elms and may still exist beneath the ground level. The Butter Cross was still standing in 1795, but was finally removed in 1811.

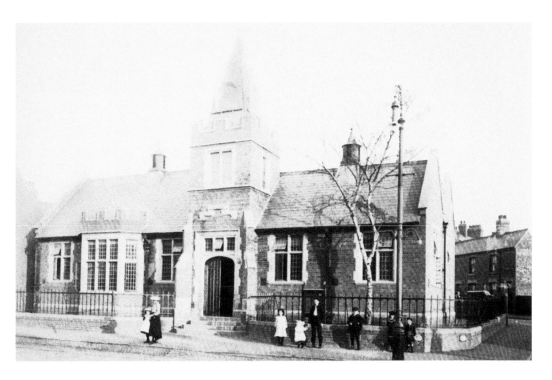

### The Carnegie Museum

This attractive building was a former Carnegie library built in 1905 with funding from the wealthy industrialist and philanthropist Andrew Carnegie. After refurbishment by Leicestershire County Council in 1977, it reopened as a museum with a specific brief in addition to the local history of Melton, to reflect the local social, cultural and economic effects of foxhunting.

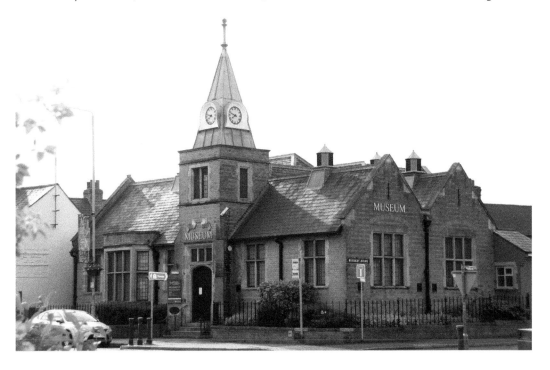

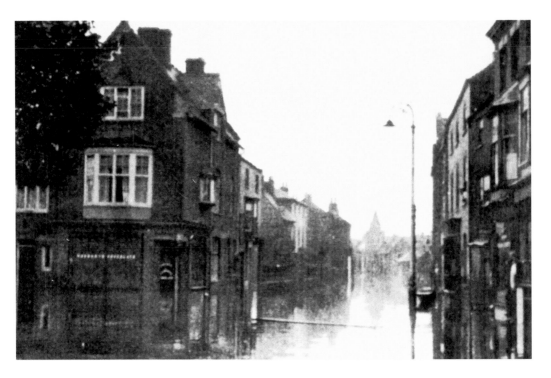

Thorpe End Floods

The earlier photograph was taken in August 1922 and records what was probably the worst flooding to occur in Melton in recorded history. The River Wreake broke its banks. The floodwaters ran along Burton Street as far as the church, and submerged the railway lines.

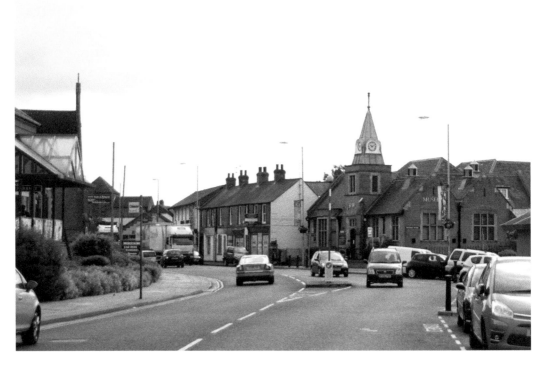

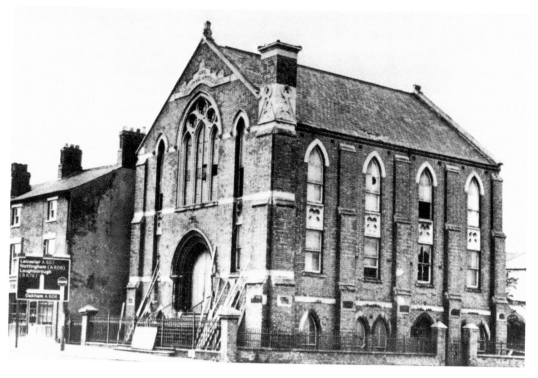

## The Primitive Methodist Chapel

The Primitive Methodists' first chapel in the town opened in 1845 in nearby Goodriche Street, off Thorpe End. Their later church, here in Sherrard Street, was built in 1888. The church itself was reached by a flight of steps above an extensive Sunday School. This photograph dates to 1965. The chapel closed in 1973 and was demolished two years later to make way for Melton's first supermarket, known as Sally Morland's.

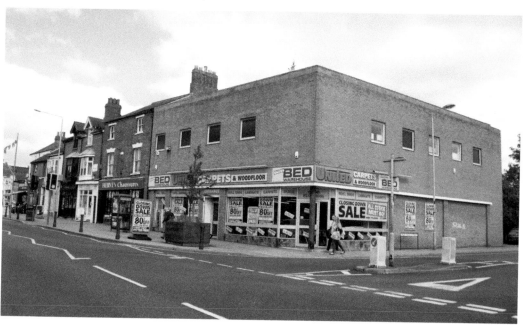

**Sherrard Street Towards Thorpe End**

This view, looking away from the town centre, with the quaint tower of the Carnegie Museum in the distance, is full of atmosphere and activity. The Primitive Methodist chapel is on the left. Moore's Café is on the corner of Sage Cross Street where Morrisons superstore now stands. The newspaper hoarding possibly refers to the sinking of the British destroyer HMS *Diana*, in which case, the date is 2 October 1940.

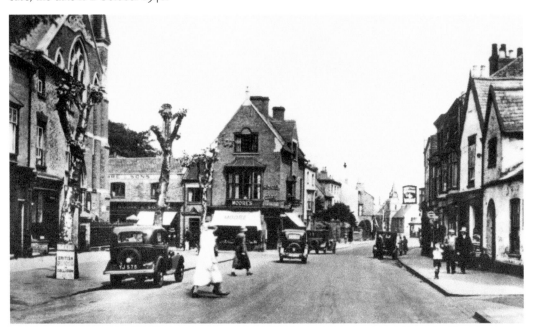

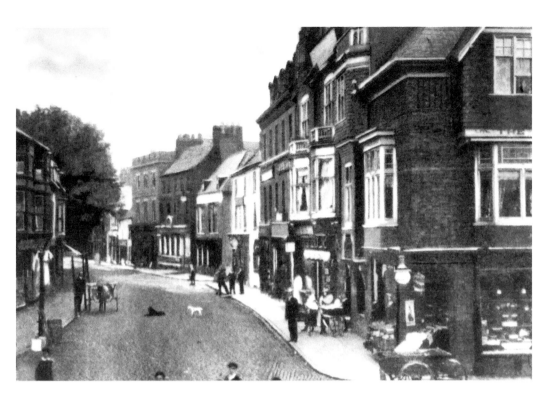

### Sherrard Street from High Street

A view towards Thorpe End, from High Street, this colour photograph dates to about 1900. Remarkably, the rooflines and upper storeys of the shops have changed little in over a century.

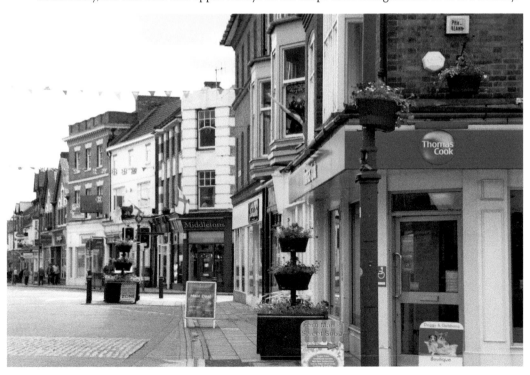

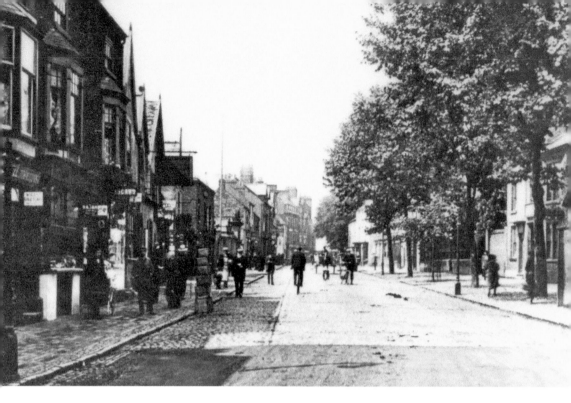

### Sherrard Street Towards High Street

Sherrard Street in the early 1920s, with no evidence of motor vehicles in this area of the town. The small street connecting with Burton Street (to the left) was known then as Lambert's Lane. It is near here that the 'beast market' was held before the first cattle market was opened. On the right, behind the trees is the entrance to The Limes.

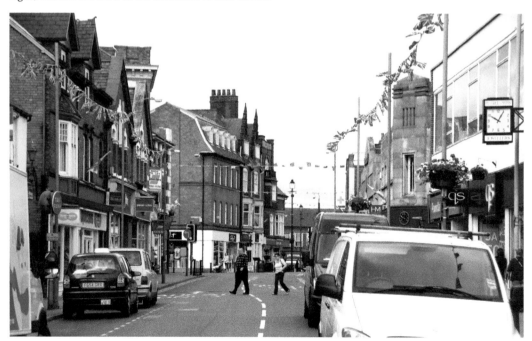

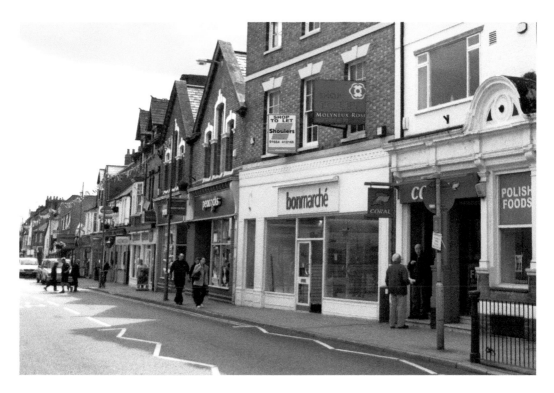

### Sherrard Street Post Office

Several buildings in the vicinity of Sherrard Street have been used as the town's post office. Today, a clothing retailer occupies the premises of Sharman and Ladbury, local agricultural engineers. The neighbouring premises has been rebuilt in the style of the adjacent garage and is also now a women's clothing retailer.

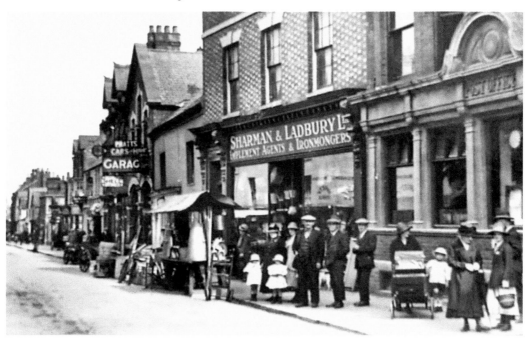

**Sherrard Street in the 1920s**

In this old photograph from the late 1920s, horse-drawn traps are still the common and familiar form of transport. The large tree marks the boundary wall of The Limes, which within a decade would be demolished to make way for more shops.

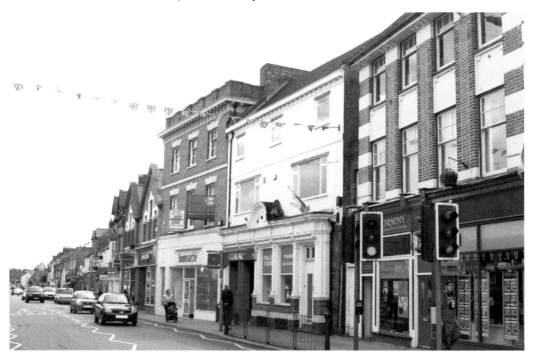

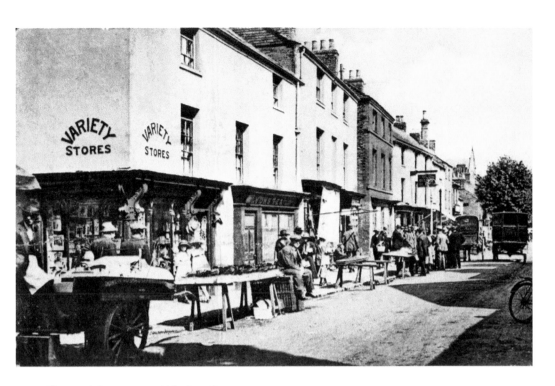

**Sherrard Street, near Windsor Street**

There is a sense of continuity in these images, namely the street clutter of market stalls. The names above the shop windows have changed over time, but the colourful stalls (and the inevitable rubbish at the end of the day) remain.

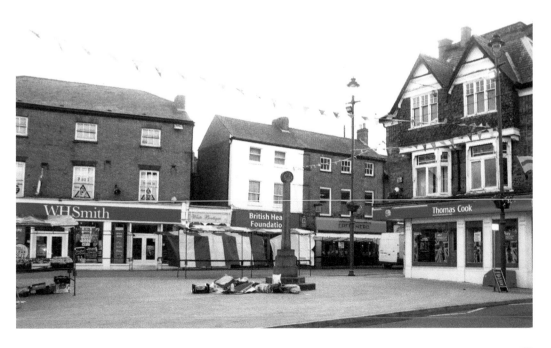

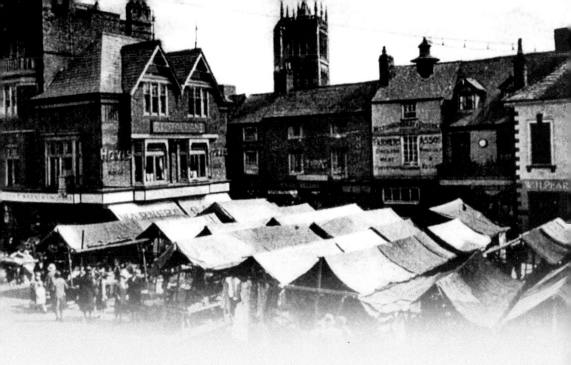

CHAPTER 4

# The Market & its Environs

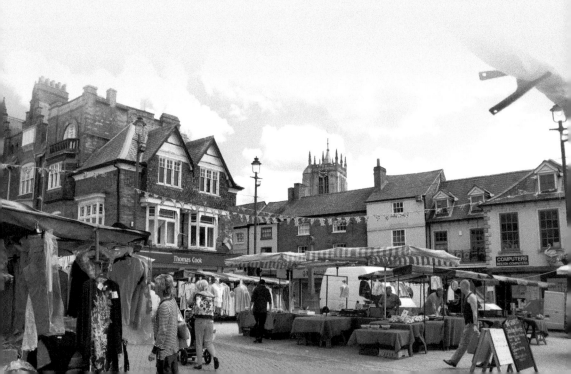

In the Domesday Survey of 1086, Melton was home to the only recorded market in Leicestershire. The market was probably first granted to the town in the reign of Edward the Confessor (1042–66) and there is a tradition that Leuric, son of Lewin, the last Saxon Lord of Melton, was granted a market at Melton by the last of the Saxon kings. The oldest documentary evidence of a market is in 1077.

There has been a market here on Tuesdays since royal approval was granted in 1324. There were originally only two fairs, one on the Tuesday, Wednesday and Thursday of Whitsun week and the other one on the Vigil Day and Morrow of St Lawrence (10 August), continuing for eight days. These two fairs were included in the list of liberties owned by the Lord of the Manor in the reign of Edward II (1307–27). By 1902 the number of fairs had increased greatly.

The buying and selling of goods, commodities and livestock was an essential activity in medieval times as it is today. Its importance is underlined in the former names of streets and open spaces such as Saltgate, the Cornhill and Beast Market. Other fairs included the New Ram Fair on the fourth Tuesday in September, the Stilton Cheese Fairs held in April, September and December, the annual Wool Sale, which began in June 1890, and the annual Statute Fair held at Michaelmas at the top of Burton Street.

Today, under the management of the Melton Town Estate, the market spills out of its ancient location along the adjoining streets including Cheapside, South Parade and Nottingham Street. Although it has the appearance of a 'confusion' of colourful characters offering seemingly unmissable bargains, it is regulated, and every trader conforms to the same retail legislation as the biggest retail names in the malls of the largest cities.

Unlike other market towns such as Market Harborough, some twenty miles away, the market in Melton preoccupies its town. In so many places, including Market Harborough, the old market has been tidied away inside purpose-built but largely soulless market halls that stand empty and silent for much of the time, leaving the old market places neat and tidy, and without character or life.

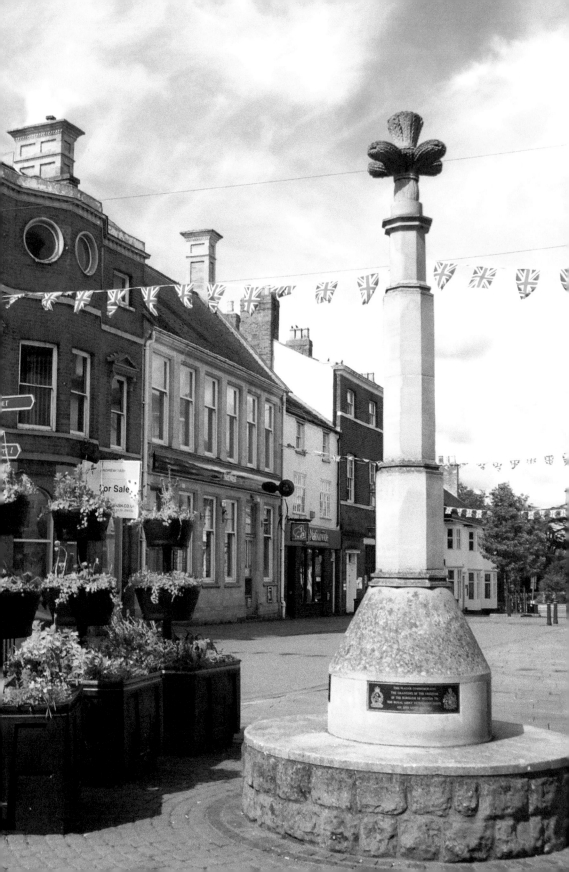

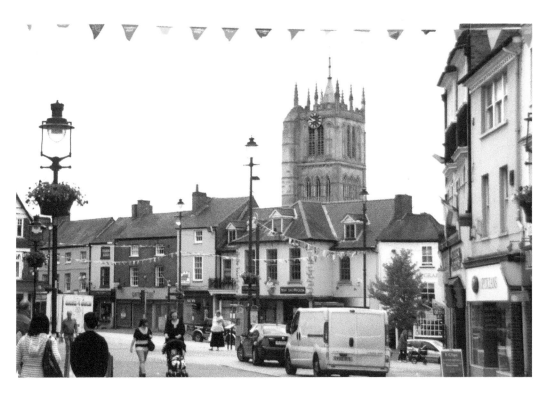

## South Parade

All Melton's streets seem to lead to the market. The tower of St Mary's parish church provides a sense of antiquity, yet the market traders were here long before the present church was built. Here there is hustle and bustle, even when the market is not being held. The varied colours of the buildings do much to brighten this historic place.

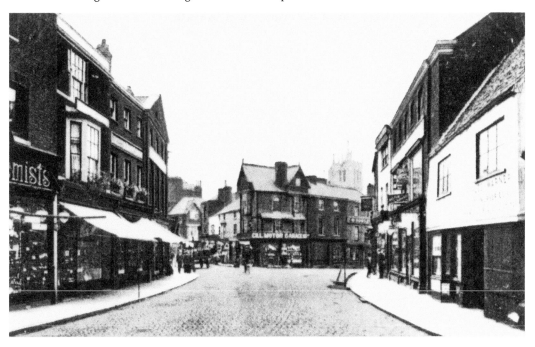

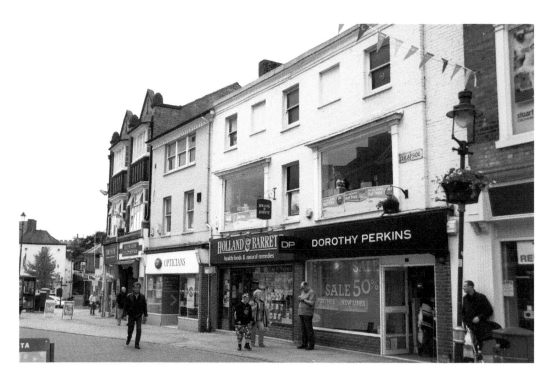

## Cheapside

South Parade merges into Cheapside, and the shops that have traded since Victorian times are still open for business, although most of the local traders' names have gone. Here, in a photograph from the 1890s, a shopkeeper stands proudly in the doorway of his premises. His family and staff line up outside on the pavement. Note the fine display of shovels and watering cans at the neighbouring hardware shop.

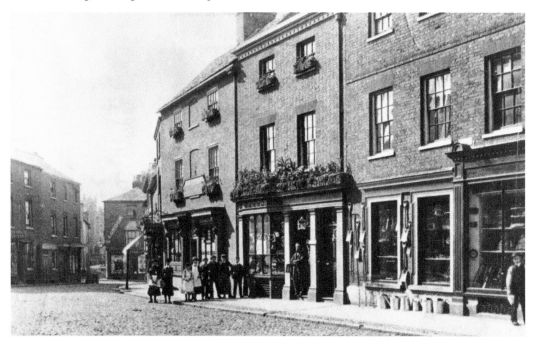

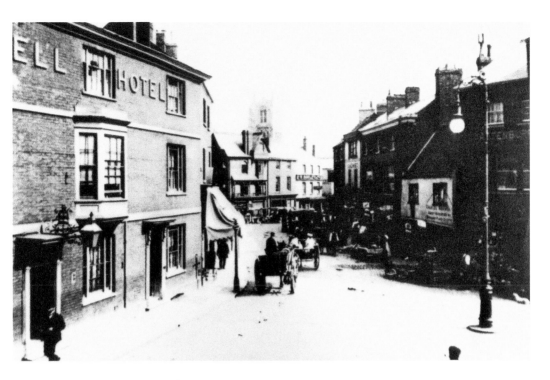

**South Parade and the Bell Hotel**

The Bell Hotel is a dominant statement of architecture in this small street. It stands facing the eastern end of the High Street where Nottingham Street and South Parade merge one into the other. Today, it is a Grade II listed building. It was built in the early eighteenth century, and its frontage dates to the early 1800s.

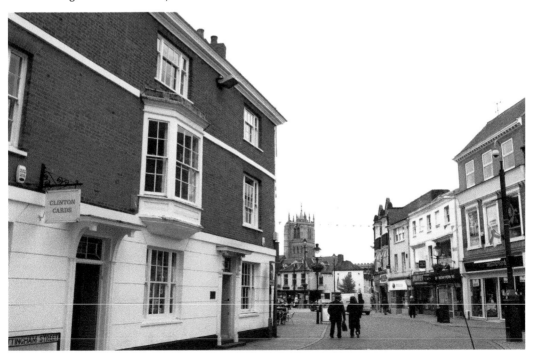

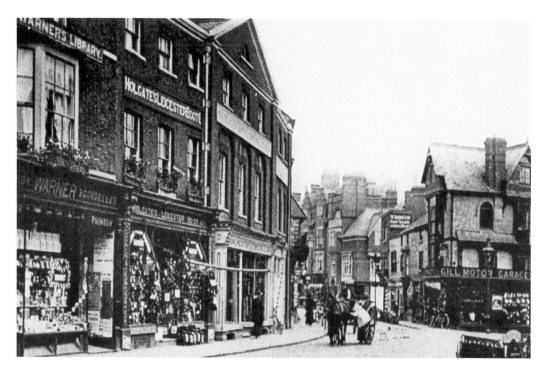

South Parade *c.* 1900

The upper storeys, windows and roof lines of these dignified Victorian buildings have hardly changed in the hundred years that have passed since this earlier photograph was taken. The wheelie bins of the twenty-first century may seem an unwanted eyesore, but towns and their retail premises have always created refuse. In 1900, the rubbish would have been placed in the backyards, out of sight and out of mind.

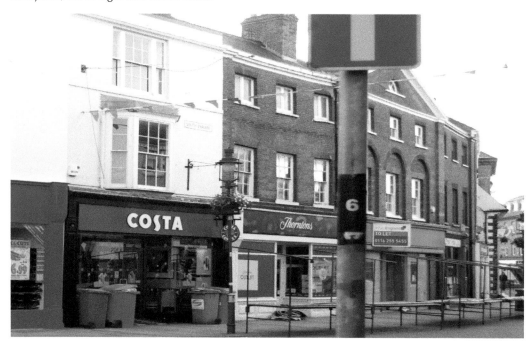

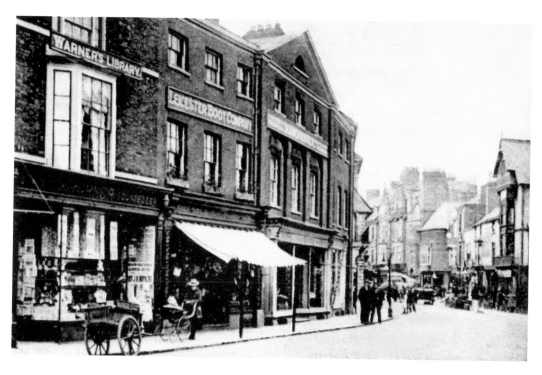

South Parade, 1905

The same view towards the market place, taken some five years after the previous archive image. By this time, the new town library at Thorpe End had opened, heralding a new era in the opportunities afforded to the working classes in terms of access to books. But the private and commercial libraries, such as Warner's here in South Parade, would continue to flourish for some years to come.

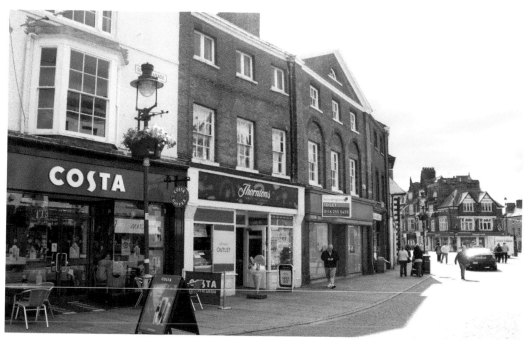

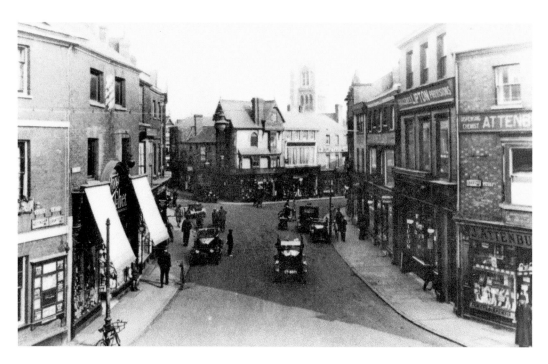

## South Parade Towards the Market Place

Both of these photographs were taken from a first-floor window overlooking the street. Motor vehicles are beginning to be an influence, and there are route signs for the A606 and A607, high up on the wall of the shop on the left of the old photograph. Until 1880, this was the main route between Nottingham and London, run by the Nottingham, Melton & Kettering Turnpike Trust. The Trusts were abolished in 1880, the same year in which Melton's railway station opened.

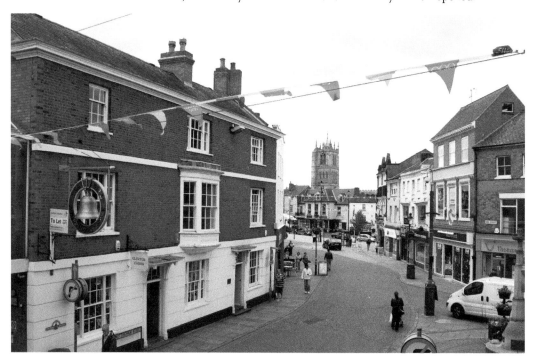

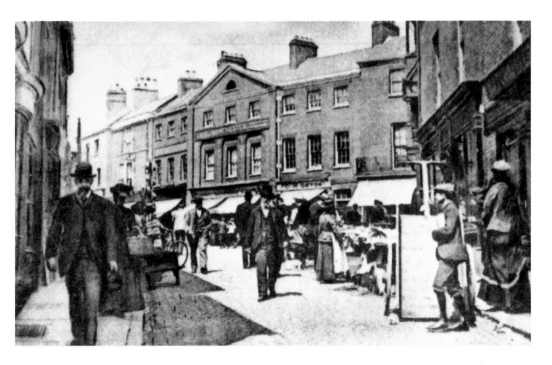

Cheapside in 1900

The stance and apparent attitude of the gentlemen in the earlier photograph suggests disdain, as if the market is not an enterprise they would choose to patronise. More than a century later, the colourful stalls still spill out into the street. Today's shoppers seem more willing to engage.

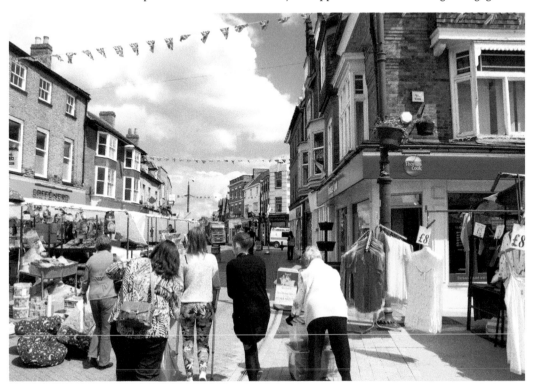

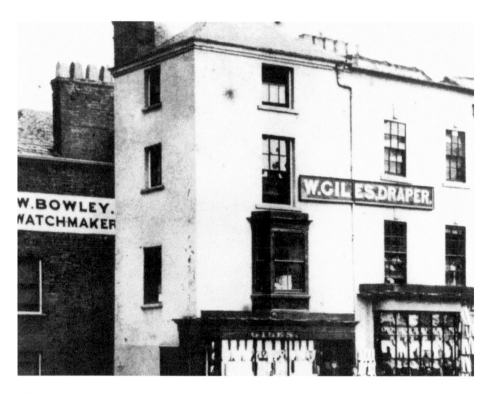

### Giles the Draper

The curtains and table linen of Mr W. Giles, Draper of Cheapside, probably found their way into almost every living room in Melton. The shop was not only a landmark but an institution. Without its familiar name and window display, the building has slipped into near anonymity.

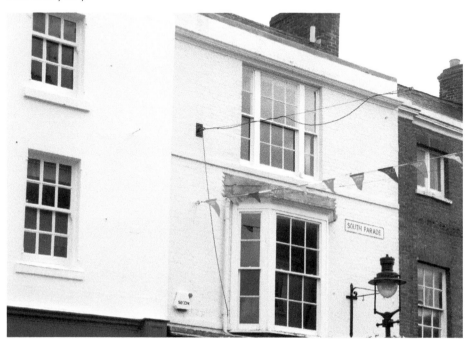

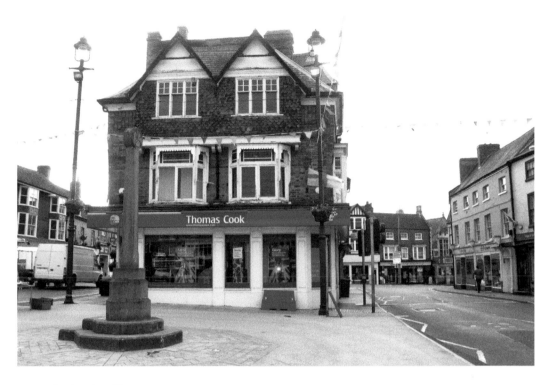

### The Market Place, 1910

Here is where the deals have been done and the bargains have been sought for centuries, and no doubt it has always been a cosmopolitan environment. True, the market served as means by which local producers of food and livestock could sell to the local community and the surrounding hamlets, but since Roman times, traders would have been selling spices and fabrics from more distant and perhaps exotic locations.

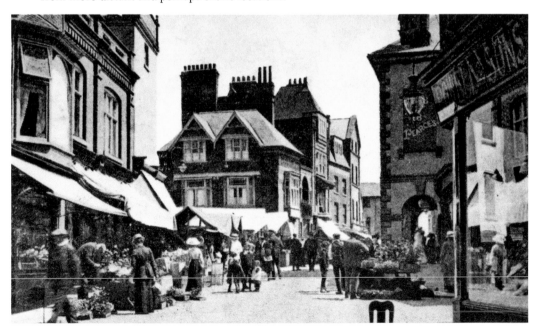

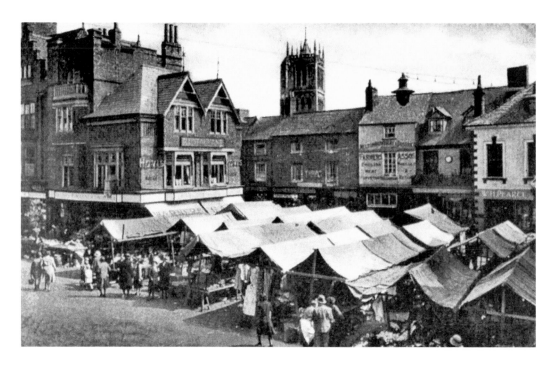

The Market Place, 1930

For many, the 1920s were not 'roaring', and the 1930s was a decade of poverty. In Melton Mowbray, as in market towns across the country, many who had little income and large families relied upon the markets for their food and clothing. Market traders had fewer overheads, and were willing to travel and to work long hours. Consequently they were able to offer an economic lifeline to innumerable people.

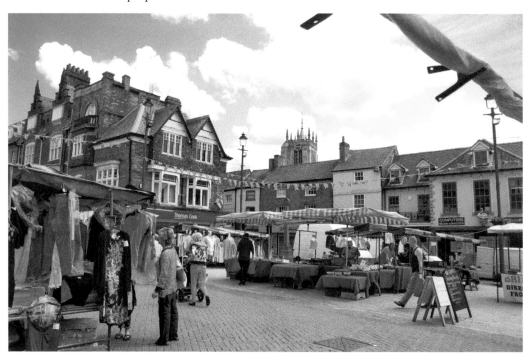

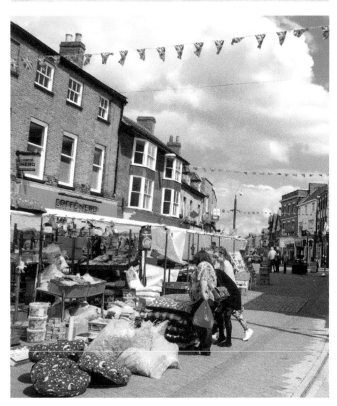

**The Market Place, 1985**
Less than thirty years separates these two images, and to some extent it would seem that little has changed in that time. But 1985 was a key year for the British economy. It was the year of the Miners' Strike and of Bob Geldof's Live Aid concerts, and in nearby Asfordby, a new pit was sunk that was never to produce any coal.

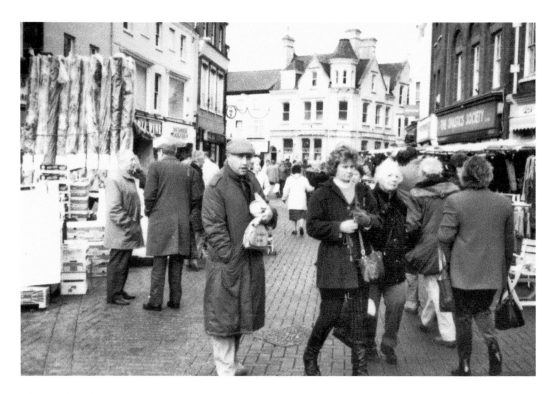

**The Market Place, 1992**

Even more recently, shoppers peruse the market stalls on a cold morning in 1992. By this time, the modern image of Melton had been created, with its paved pedestrian areas. This was the year the European Union was founded. In September, on 'Black Wednesday', the pound was forced out of the European Exchange Rate Mechanism and in this same year Her Majesty the Queen announced that she would, in the future, be paying income tax.

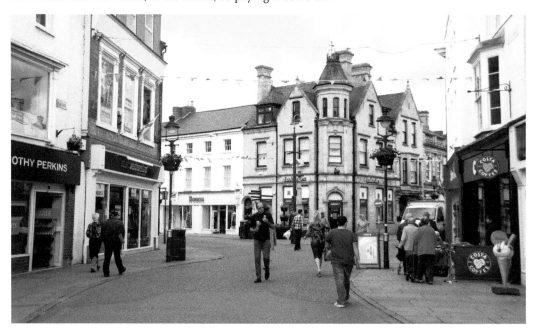

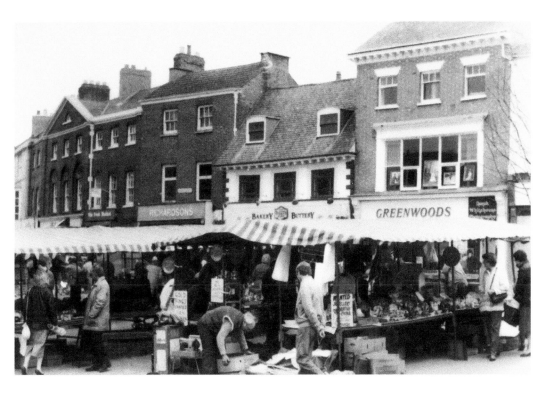

**Antiques Market, 1985**

An antiques market in the market place in 1985. Arthur Negus, arguably the man who brought the concept of antique valuation into everyone's living rooms, died on 5 April of this year. Three weeks later, and shortly before the Melton Antiques Market opened, the BBC *Antiques Roadshow* was recorded in nearby Nottingham.

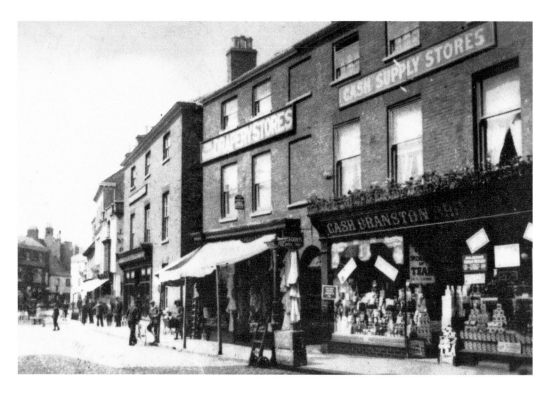

### Cash Supply Stores

Drapery and general household goods on sale in the market place. Branston Brothers were following a shopping trend across the country in dealing only in cash and thus keeping prices down. Perhaps the best-known of these stores is J. K. Wilkinson, who opened his first store in Leicester's Charnwood Street in 1930 to later become a household name.

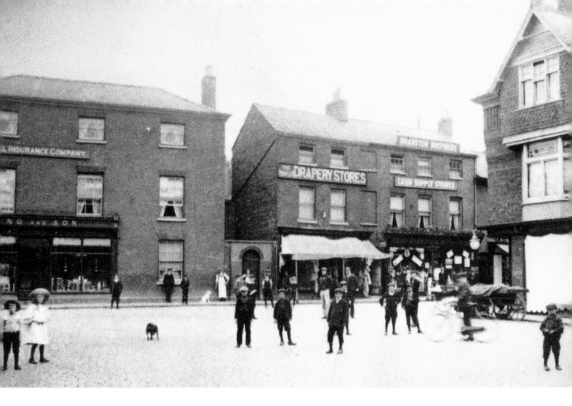

## The Market Place

Children congregate in the market place in the twentieth century, very aware of the photographer. The Drapery Stores and Cash Stores of the Branston Brothers occupy a prime position, as do Wing & Sons and the offices of the Royal Insurance Company. In 1987 the Butter Cross was rebuilt using what was thought to be its original base, which was found in St Mary's churchyard. It is believed that the 'new' Butter Cross has been erected on the same site as the old Saxon Cross.

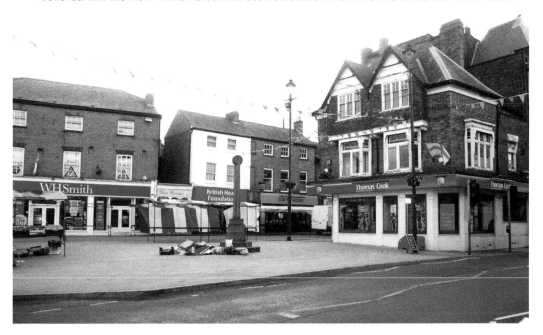

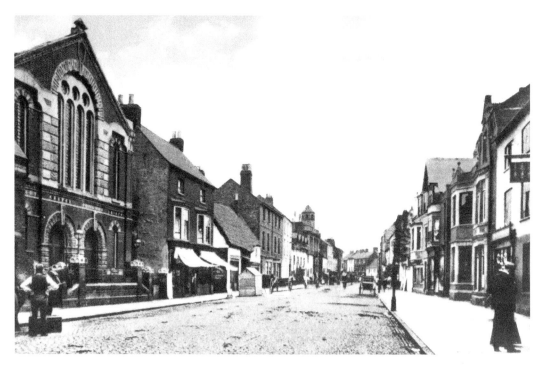

**Nottingham Street, 1887**

A very early colour photograph of Nottingham Street looking towards High Street. One of the oldest streets in the town, until about 1850 it was known as Spital End or Spitalgate because the land was owned by the Knights Hospitaller from the fourteenth to the sixteenth centuries.

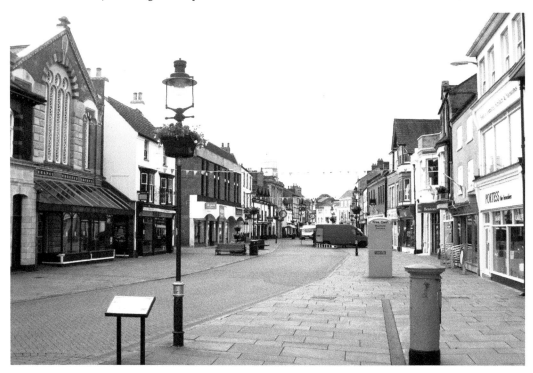

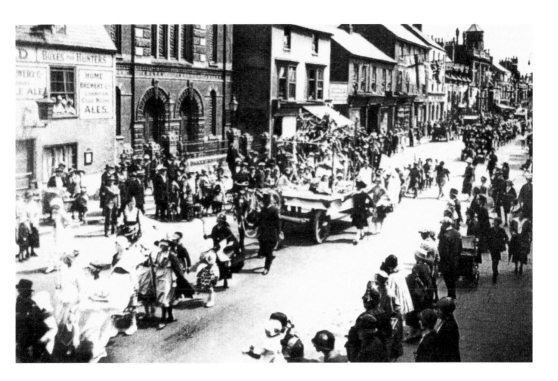

### Nottingham Street Parades

Near to the old Baptist church stood the Sheep Cross, where the sheep market was originally held. At the junction with High Street stood the Corn Cross, where the corn markets were held. Nottingham Street has been a place for parades, carnival and celebration, as the older photograph shows so well. Today, parades extend to the modern outskirts of the town.

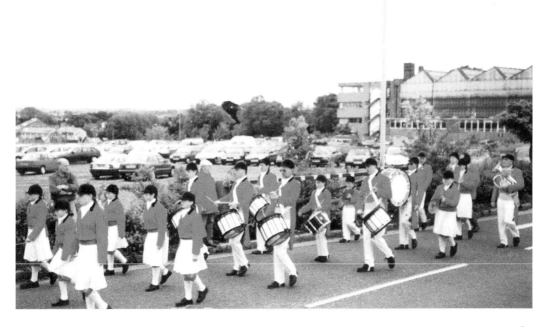

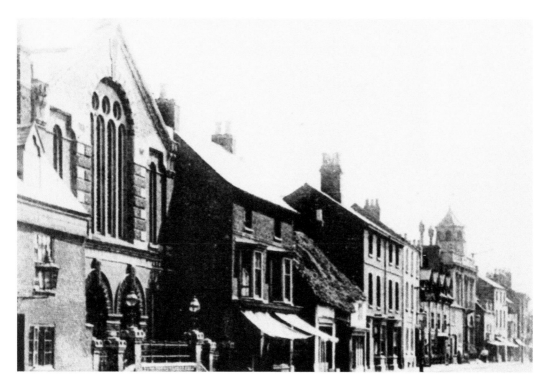

**Nottingham Street Baptist Chapel**

The Baptist movement came late to Melton Mowbray. Their first meeting place was a small Calvinist Baptist chapel on Timber Hill, some distance away, which was set up in about 1850. The chapel in Nottingham Street was erected in 1872 and is now a Grade II listed building.

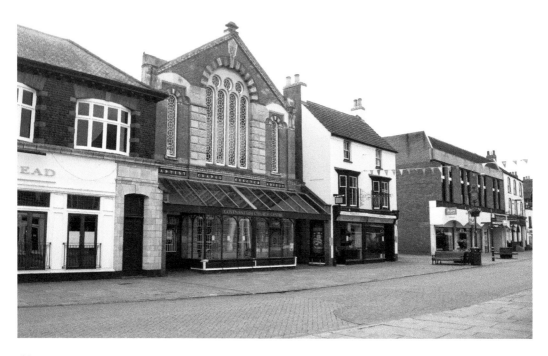

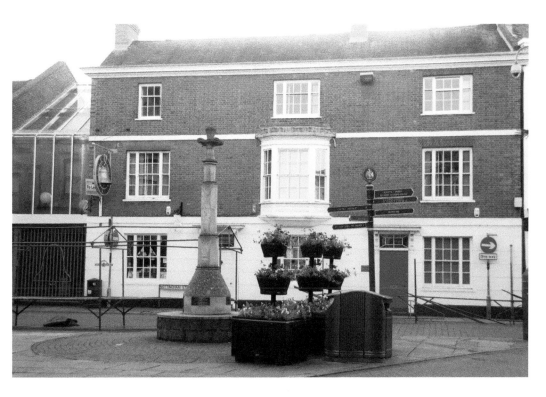

**Nottingham Street from High Street, c. 1910**

A view along Nottingham Street towards the Scalford Road end, with the imposing frontage of the Bell Hotel facing the High Street. Melton has lost almost all remnants of its original crosses. This new Corn Cross replaced the original, which stood one this spot until about 1797.

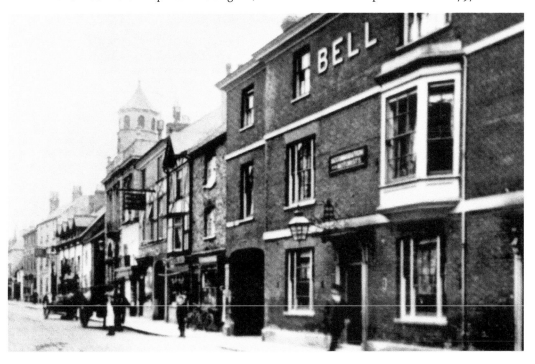

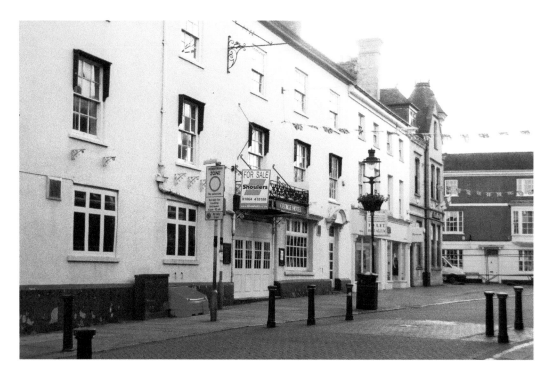

## High Street

The High Street is no longer the focal point for trade in Melton. As the main route between the main road from Leicester and the town's market place, it was formerly a busy coaching location, hence the presence of the two ancient coaching inns. There is no evidence of the Corn Cross in this photograph from about 1913.

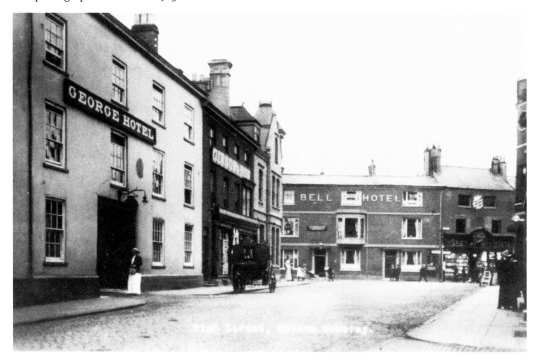

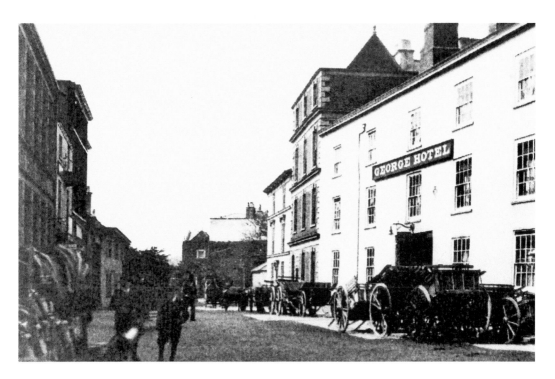

**High Street Towards the Leicester Road**

A scene not dissimilar to the modern bus station, with stagecoaches arriving from Leicester and Grantham, their passengers taking rest and refreshment at the George Hotel. In earlier times, this was known as Swines Lane, presumably being a route to bring cattle for sale at the market or down to the River Eye to drink. In the distance is Egerton Lodge.

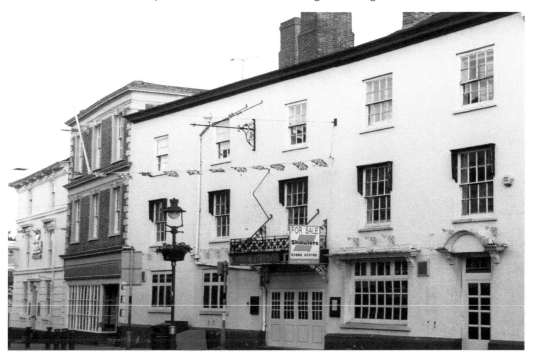

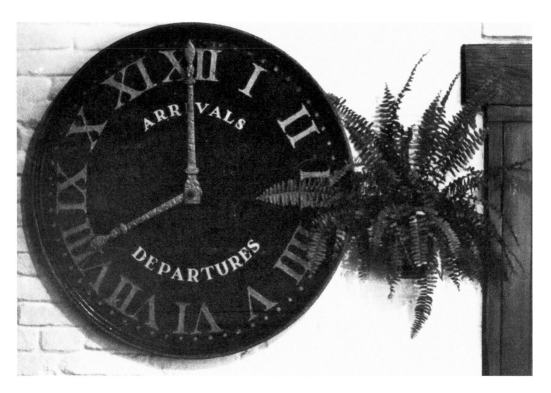

## The George Hotel's Coach Clock

In its heyday, the George was the hub of travelling activity, its unique clock advising travellers of the arrival and departure of the stagecoaches to London. This old coaching inn has lost so much of its earlier importance and dignity. Parts of the rear of the hotel date from the 1600s. It closed in December 2010, and although the building has Grade II listed status, and still shows signs of an original centre carriageway, its future is uncertain.

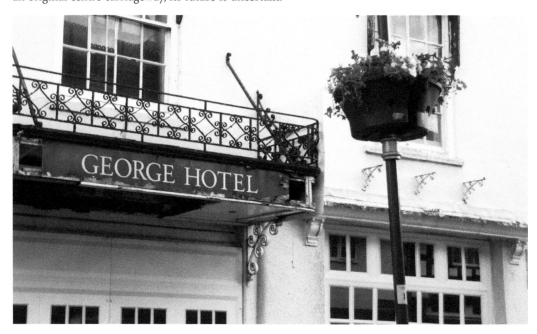

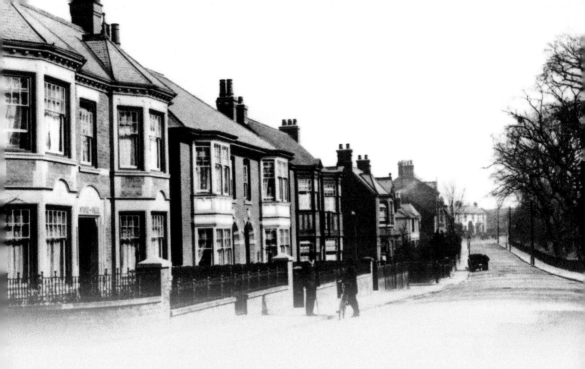

# CHAPTER 5

# The Leicester Road & the Turnpikes

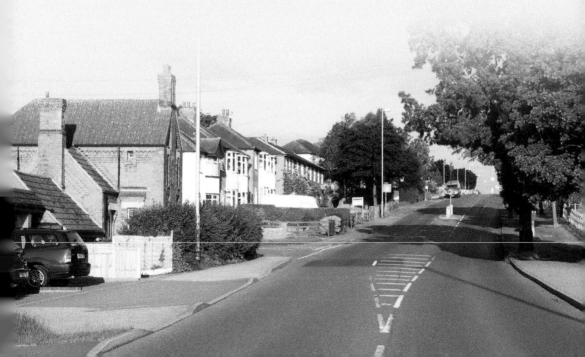

M elton Mowbray has had trading connections since Roman times and was an important centre for the wool trade from the fourteenth century, but it was the successive turnpike acts of the seventeenth and eighteenth centuries that placed the town firmly on the national map.

The first road to be turnpiked was the route from Nottingham to London, through Oakham, Uppingham and Kettering, which received Parliamentary assent in 1753. The route to Leicester, and beyond to Lutterworth, was approved ten years later, and in 1779 assent was given for the route from the Sage Cross in the town to Grantham. Hence by the end of the eighteenth century, the town was, effectively, a crossroads for stagecoaches and other traffic.

As the Leicester Road enters the town, it crosses the River Eye, originally at a ford. This crossing point gave travellers along this route their first glimpse of the tower of St Mary's parish church, and was undoubtedly the moment when visitors to Melton knew they had reached their destination.

At the Nottingham Road junction, several routes diverge. The Asfordby road still provides a journey through time for the traveller, passing former hunting lodges and deserted medieval villages as well as Victorian and Edwardian residential developments. Asfordby Valley and Asfordby Village, though still enjoying their own individuality as settlements, are now almost part of the greater Melton town area.

Ever present is the river twisting through its valley, here changing at Sysonby Lodge to the descriptive name given to it by Danish settlers, Wreake, meaning the twisting or meandering one.

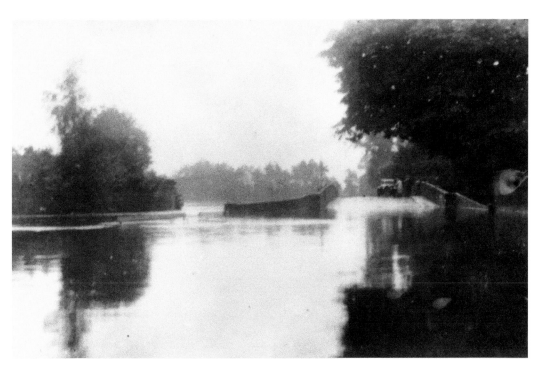

### The Leicester Road in Flood

The floods of 1922 were the worst ever recorded in the town. This rare photograph, looking from near the junction with High Street, provides an impression of the bleakness of the situation, with a car and its occupants stranded on the bridge.

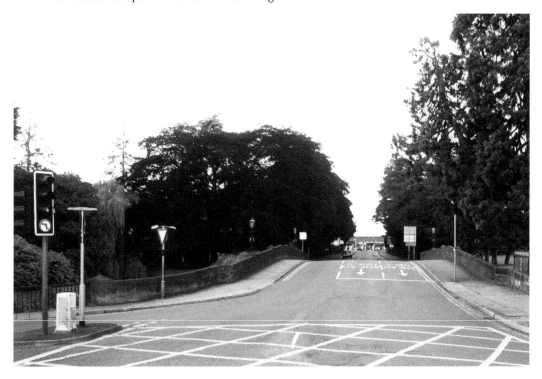

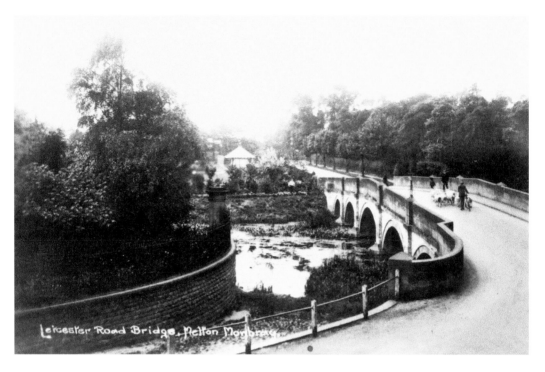

Leicester Road Bridge

The river in quieter times, with livestock being herded over the bridge. On either side of the road and river are the landscaped grounds maintained by the Melton Town Estate.

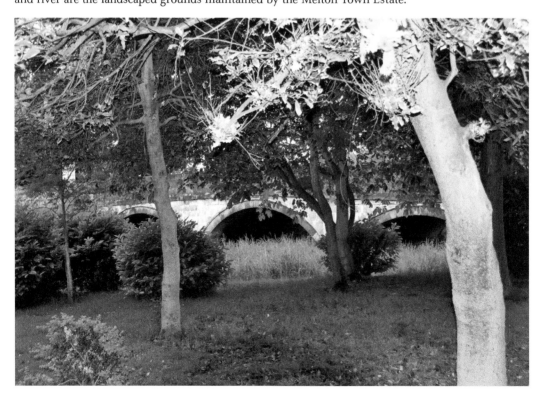

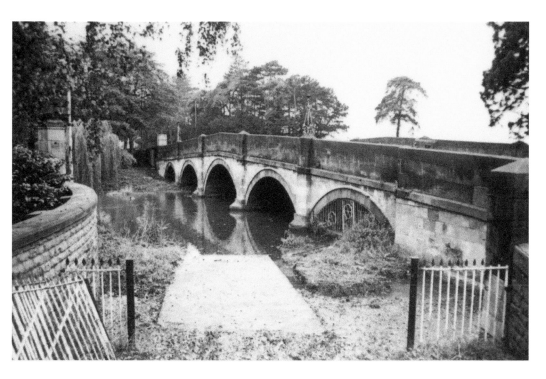

Leicester Road Bridge, 1974

A more recent photograph of Leicester Road and the River Eye (which becomes the River Wreake a short distance from this point). Without either traffic or people to provide a clue to the date, this appears as a timeless scene. The river seems almost fordable at this time.

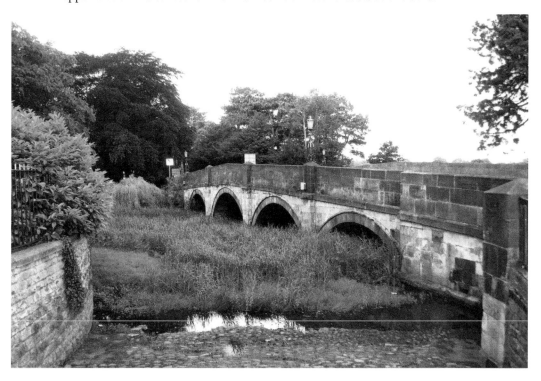

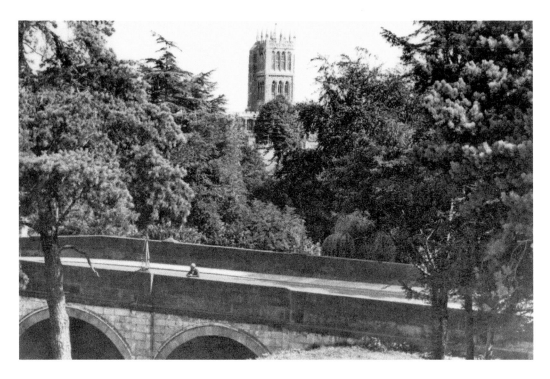

**St Mary's from Leicester Road, 1980**

This is the view that has welcomed travellers from Leicester to Melton for many centuries, the parish church appearing to stand almost on the banks of the river but separated by the town's Wilton Park, a valued expanse of landscaped parkland protected from development by the ancient Town Estate.

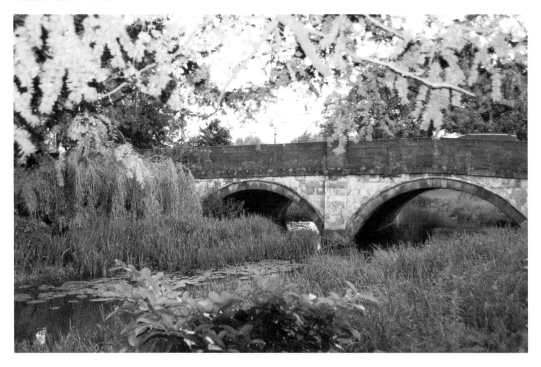

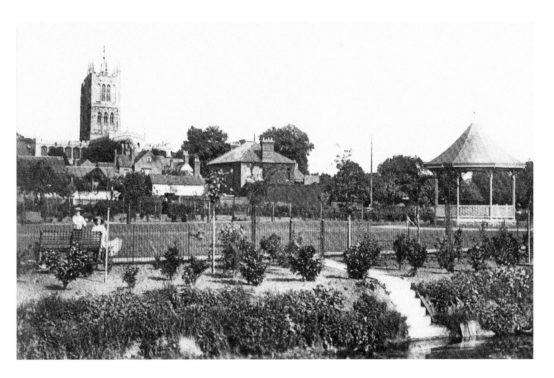

**Wilton Park**

Here is Wilton Park in earlier times, with many of the trees and hedging appearing to have been recently planted. It was originally a field and was purchased from Lady Wilton in 1919 for the sum of four hundred pounds. The design of this park epitomises the spirit of Edwardian times, and serves today as the centre of sporting activities in the town parks and as the venue for the annual Melton Fair.

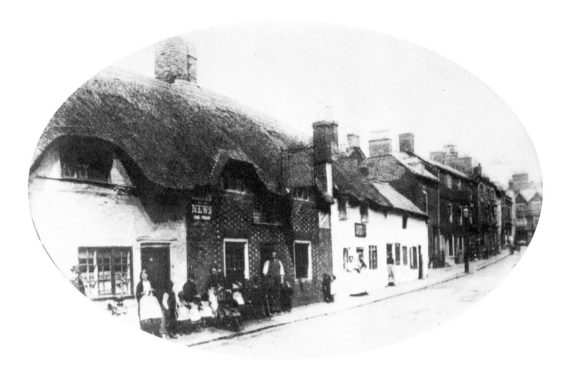

Leicester Street, 1890
This is a view towards the centre of the town along Leicester Street, which connects Leicester Road with the market place. The photograph was taken in 1890 when the street was still a mix of residential and commercial properties, thatched cottages and inns, standing side by side.

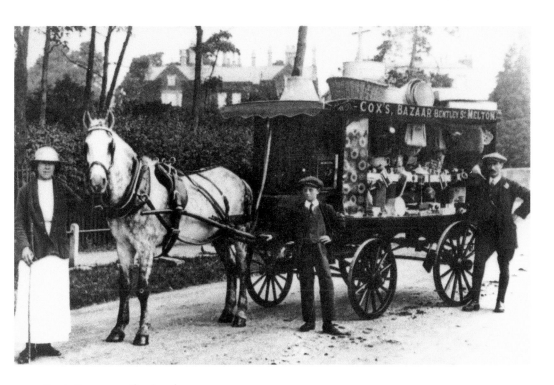

Cox's Bazaar on the Road

Taken in Leicester Road, with Egerton Lodge in the background, this photograph shows the Cox family of Bentley Street standing proudly by the side of their mobile shop. Although the age of the travelling shop has almost passed, Melton's streets are still occupied on several days each week by traders, some of whom still travel from market to market.

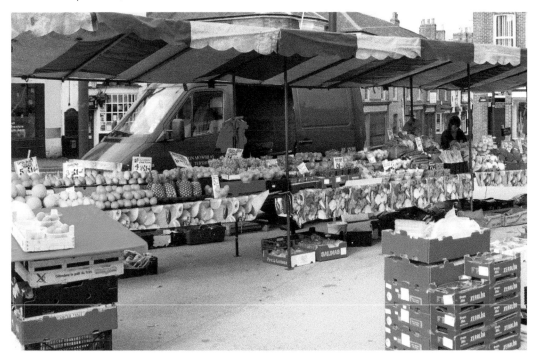

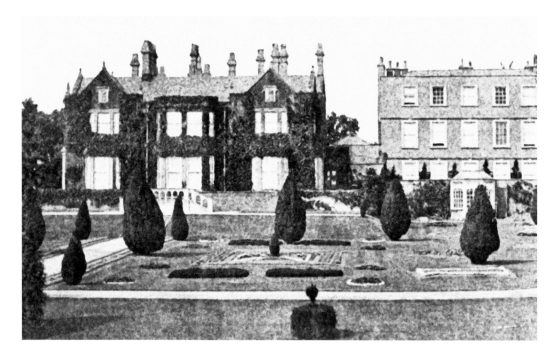

## Egerton Lodge

The stately Grade II listed Egerton Lodge dates from 1829, but was designed by Wyatt in Jacobean style. It was built for Lord Wilton as a hunting lodge. The Town Estate acquired the gardens in 1929. These were developed over the years, and subsequently became memorial gardens with a permanent war memorial erected in honour of the victims in both World Wars. The yew trees, originally planted in the eighteenth century, are being restored to the original candle flame shape; although some local people remember a previous shape, which legend says reflected the tears of Lord Wilton when his wife died.

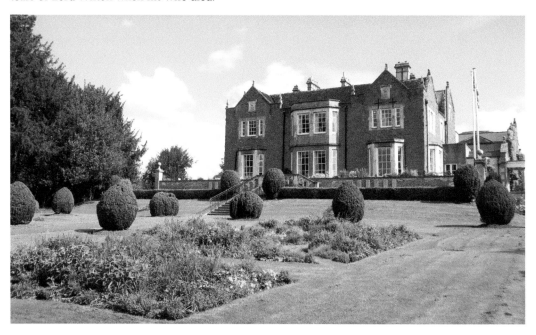

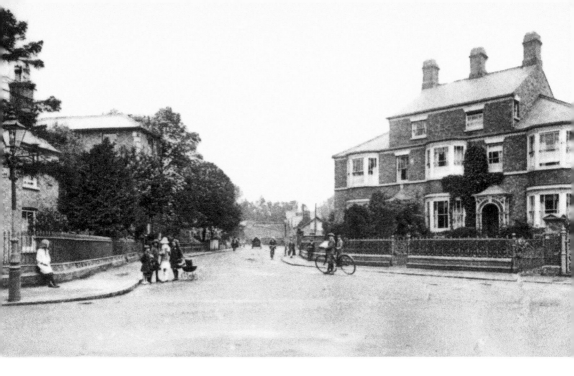

## Nottingham Road Junction

An important intersection close to the town centre, where three routes from Leicester, Nottingham and Loughborough (through Asfordby) merge. The house on the right, which was once in a tranquil rural setting, is now surrounded by the clutter of street furniture.

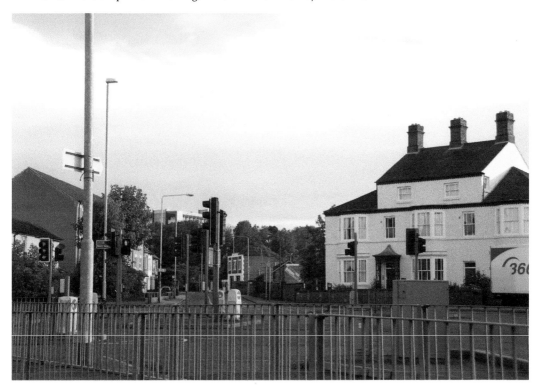

## Ankle Hill and the Memorial Hospital Grounds

According to legend, Ankle Hill is the site of the 1645 Civil War battle in which 300 men were killed, their blood running ankle-deep, but the road names have changed. In 1760 the first house to be built on the south side of the river was erected here. With its landscaped gardens it was purchased for the town in 1920 and became a hospital. No longer used by the NHS, the area has now fallen into decay and the buildings are ruinous.

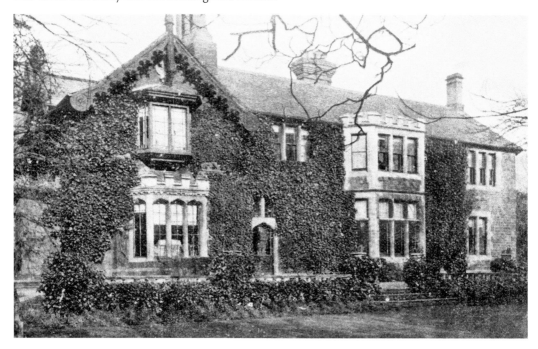

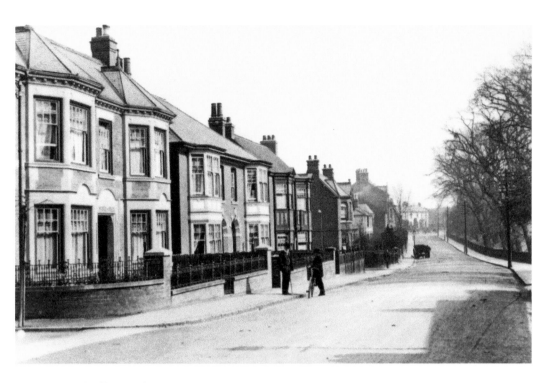

### The Asfordby Road

Sedate residential development is visible along the Asfordby Road, although this was to become a busy route through the Vale of Belvoir towards Loughborough and East Midlands Airport. The Asfordby Road golf course, laid out by the Town Estate in 1974, is on the site of the deserted medieval village of Sysonby.

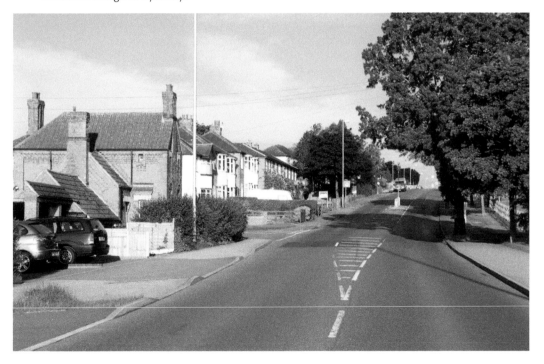

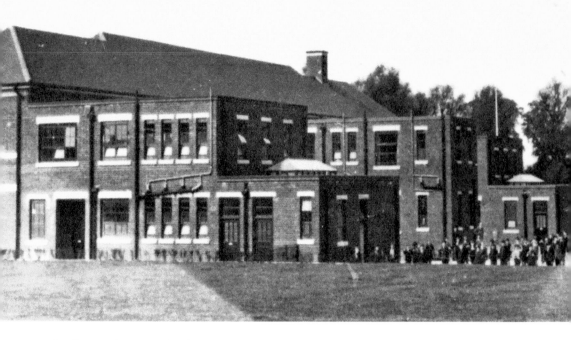

## Asfordby Road Grove School

Built in the 1930s, the architecture of this school is very typical of its time, functional but hardly inspiring. However this solid and square structure in brick continues to fulfil its purpose as a school for the district. Today it has another educational establishment as a neighbour, the Brooksby Melton College.

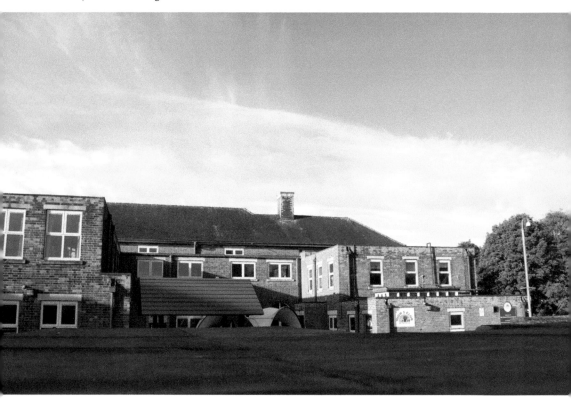

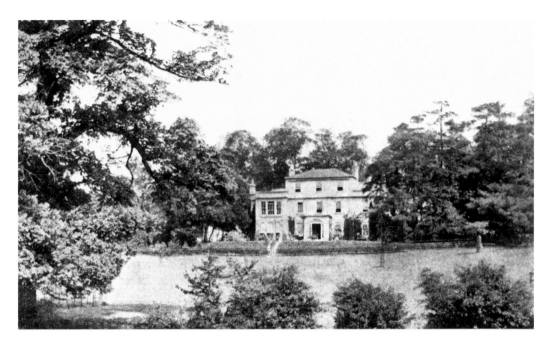

**Sysonby Lodge**
Sysonby is a deserted medieval village near to the River Wreake and close by the Asfordby Road. Its name lives on in the small church that still stands, in the lane that runs beside the modern golf course, and in the nearby hotel, a converted hunting lodge.

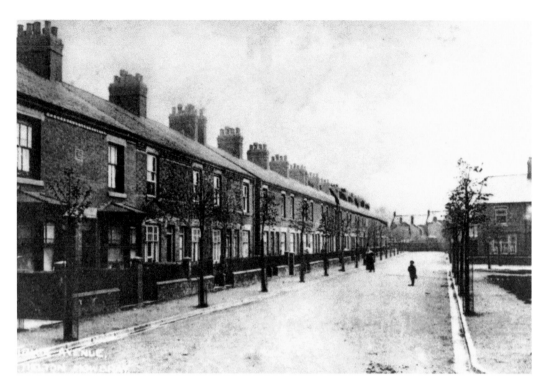

Fernie Avenue

Part of a network of little residential streets off the Asfordby Road and named after one of the famous hunts of the area. In this photograph, which dates to the end of the nineteenth century, the trees look no more than a few years old. Unlike many similar housing estates of the time, this area was designed with green spaces to break the monotony of the terraced rows.

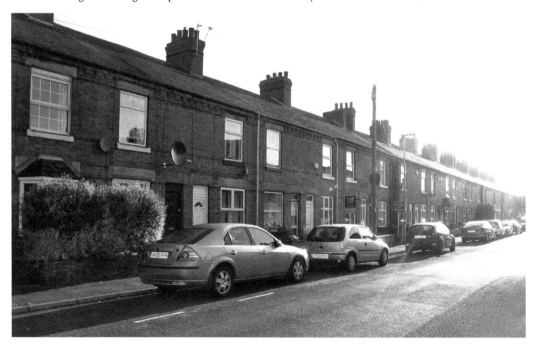

### Bishop Street Bomb Damage

Due to its proximity to military air bases and factories manufacturing military supplies, it is surprising that Melton suffered so little damage from enemy bombing during the Second World War. But it still shared in the suffering of so many, as this photograph from 1943 graphically illustrates.

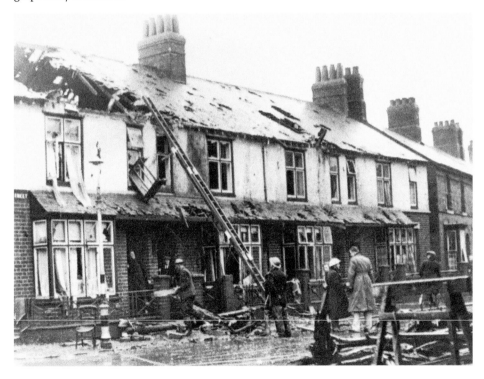

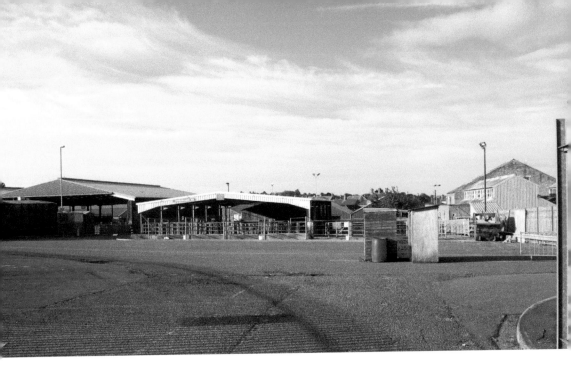

### The Cattle Market

Livestock has been exchanged by sale in the town for many centuries. Indeed, the ancient 'beast market' was held in one of Melton's busiest streets until an area was set aside on the outskirts. Today there is still a cattle market on every Tuesday throughout the year. The site has a strong historical link with the town, being part of the land known as Chapel Close, which in 1549 was given to Melton to provide an income for the Town Estate.

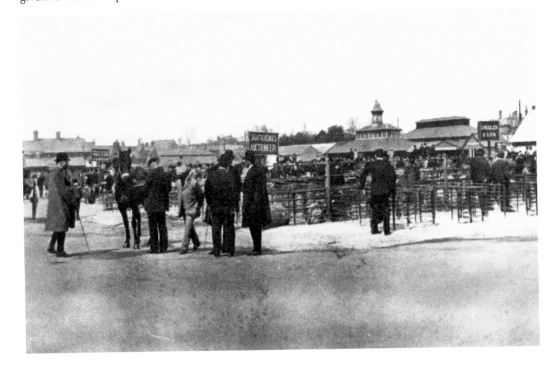

CHAPTER 6

# Melton Mowbray & the Hamlets

The history of Melton Mowbray is linked strongly to the hamlets and villages that surround it. Although at the time of Domesday some of these settlements were almost as large as Melton in terms of population, it was the town that, over the centuries, was to grow to become the economic focus for the area.

The connections of the past are through land ownership, religious administration and commercial necessity. The five hamlets most closely associated with the town all looked to St Mary's in Melton as their parish church, and the Mowbray family's ownership of lands in the area over the space of 400 years formed bonds in land ownership that can still be found today.

The story of John de Woodford is an example of how these relationships were linked, and were deeply rooted over the centuries.

Woodford was a soldier from Wiltshire who fought at Crécy and Poitiers alongside John de Mowbray. His fighting days over, he settled in Melton, perhaps at the invitation of de Mowbray, purchasing land and property in the town and subsequently marrying the daughter of Walter Prest, Melton's wealthiest wool merchant.

In time, Woodford acquired further land. He lived out his years in the tiny hamlet of Brentingby, near to the River Eye and less than three miles from Melton, a manor he had purchased in 1318. Alice, his wife, died in 1333, and it seems that Woodford inherited a substantial proportion of her family's wealth and gave some of it to the chapel at Brentingby, which was rebuilt at about this time.

It appears that both Walter Prest and his son were victims of the Black Death, which reached Melton in 1348, as there is no record of any transaction relating to them after that date. In 1362, John de Mowbray died at York of the plague. The last known record relating to John Woodford dates also from this year, being the transfer of his lands and property to his son, William.

It is from William's time that the earlier of the two bells that once hung in the unusual saddleback tower of the church was cast. Its maker was Johannus de Yorke, who probably travelled to Brentingby with his equipment and cast the bell in the chapel's grounds, in about 1380. It is the oldest church bell in the country to which a date can be ascribed.

The Woodford family prospered at Brentingby. William Woodford acquired further land and manors, and these were added to by subsequent generations. A further bell was purchased some time before 1500. At some point, the old bell developed a crack, and its discordant note prompted local people to describe both bells as the 'Brentingby pancheons'.

In 1950, the chapel closed as a place of worship and was declared redundant in 1978. By this time the building had begun to decay and the frames holding the bells in place had become unsafe. They were finally taken down and placed on the floor of nearby Thorpe Arnold church. The older bell was later moved to Melton where it remained in the south transept of St Mary's until 1986, when the Bell shopping precinct was created in Melton's former corn exchange. The bell was put on display in the precinct and remains there today.

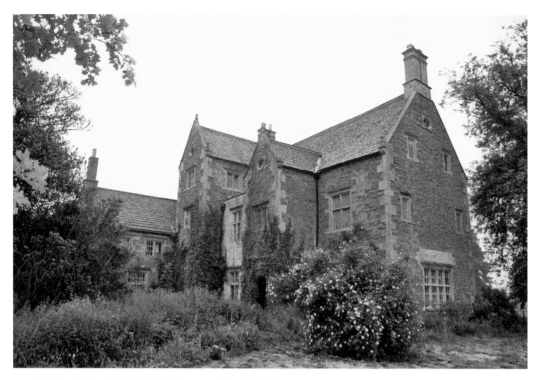

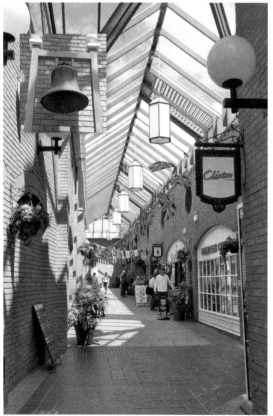

### Brentingby Hall and Manor

The present hall dates from the 1650s and is probably close to the original moated building of John Woodford's time. The complete inscription around the Brentingby Bell is no longer visible due to its current mountings. It is thought that its maker, Johannus de Yorke, relocated his foundry to Leicester, perhaps by the time this bell was cast.

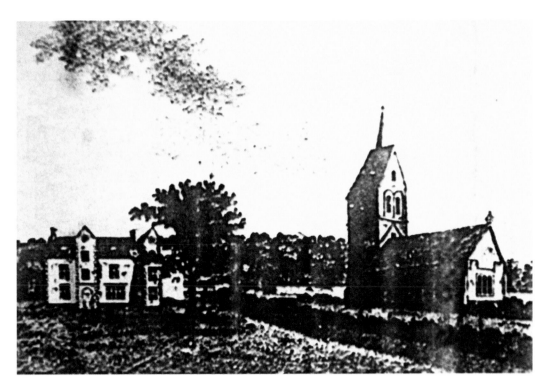

**Brentingby Chapel**

This is the earliest known representation of the chapel at Brentingby. Although indistinct, this image is important as it seems to depict the earlier Woodford manor house, which was demolished in the seventeenth century. The roof of the chapel was lowered in the fifteenth century.

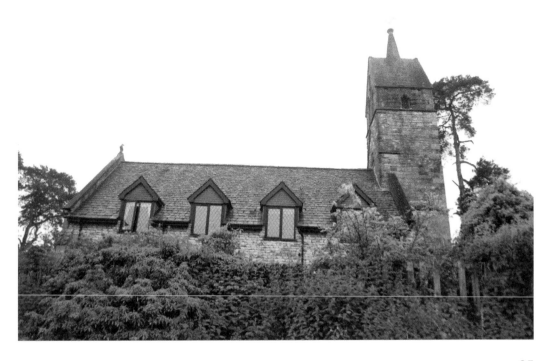

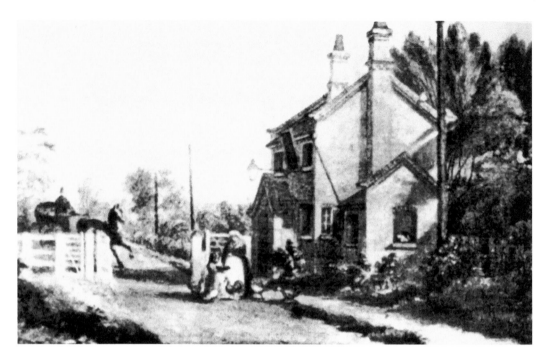

## Thorpe Arnold Toll-gate

Thorpe Arnold church was the final resting place of John de Woodford. In 1856, William (Peppermint Billy) Brown was hanged for shooting and stabbing seventy-year-old Edward Woodcock, the Thorpe Arnold toll-gate keeper, and his grandson James, aged just ten years. This was the last public execution to take place at Leicester Prison. Peppermint Billy's descendants still live in the area.